. . .

ON THE POLITICAL IMAGINARY

TANIA BRUGUERA

• • •

ON THE POLITICAL IMAGINARY

Helaine Posner
Gerardo Mosquera
Carrie Lambert-Beatty

CHARTA

DESIGN CONCEPT
Jason Pickleman

DESIGN COORDINATION
Mario Piazza, Letizia Abbate (46xy studio)

EDITORIAL COORDINATION
Filomena Moscatelli

COPYEDITING
Emily Ligniti

COPYWRITING AND PRESS OFFICE
Silvia Palombi

US EDITORIAL DIRECTOR
Francesca Sorace

PROMOTION AND WEB
Monica D'Emidio

DISTRIBUTION
Antonia De Besi

ADMINISTRATION
Grazia De Giosa

WAREHOUSE AND OUTLET
Roberto Curiale

COVER
Untitled (Havana, 2000), 2000
Video Performance Installation
Cubans, milled sugar cane, black-and-white monitor,
and DVD player and disc
La Fortaleza de la Cabaña, 7th Havana Biennial

PHOTO CREDITS
Photographs of the artist's work are
© Tania Bruguera
Photographs taken by Marcos Castillo; Centro de
Arte Contemporáneo Wifredo Lam, Havana;
Ricardo G. Elías; Esfera Pública; José A. Figueroa;
Jim Frank; Rainer Ganahl; Grandal; Donna Hurt;
Institute of International Visual Arts, London;
Sebastian Isacu; Giuseppe Liverani;
Hudson McDougall; Mailyn Machado;
Museo de Bellas Artes, Caracas; Museo Patio
Herreriano, Valladolid, Spain; Museum of Modern
Art, Warsaw; O.K Centrum für Gegenwartskunst,
Linz, Austria; Laura Oxendine; Sandra Patron;
Manuel Piña; Matt Roberts; Bob Schweitzer;
Carlo Simula; Casey Stoll; Tate Modern, London;
The Western Front, Vancouver; Michael Tropea;
Yuneikys Villalonga; César Delgado Wixen;
Edward Woodman; and Artur Zmijewski.

We apologize if, due to reasons wholly beyond our
control, some of the photo sources have not been
listed.

Edizioni Charta srl
Milano
via della Moscova, 27 - 20121
Tel. +39-026598098/026598200
Fax +39-026598577
e-mail: charta@chartaartbooks.it

Charta Books Ltd.
New York City
Tribeca Office
Tel. +1-313-406-8468
e-mail: international@chartaartbooks.it
www.chartaartbooks.it

*This book is published in conjunction
with the exhibition*

TANIA BRUGUERA:
ON THE POLITICAL IMAGINARY

organized by
Neuberger Museum of Art,
Purchase College,
State University of New York, Purchase

and presented from
January 28ᵗʰ – April 11ᵗʰ, 2010

Tania Bruguera is the first recipient
of the Roy R. Neuberger Exhibition Prize.

NEUBERGER MUSEUM OF ART
Purchase College
State University of New York
735 Anderson Hill Road
Purchase, NY 10577-1400
Tel. +1-914-251-6100
www.neuberger.com

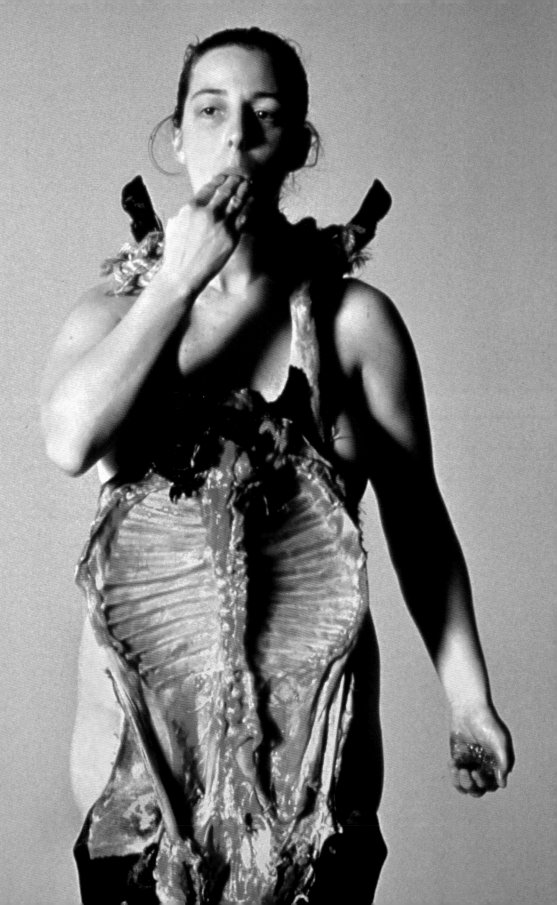

FORMER KGB AGENT,
STREET PHOTOGRAPHER, EAGLE,
MONKEY, PHOTOGRAPHIC PAPER,
PRINTER, INK,
AND PHOTOGRAPH
OF FELIX DZERZHINSKY

GERMANS, GUNS, BLACK OUTFITS,
WOOD SCAFFOLDING,
FORTY 750 WATT LIGHTS, PROJECTOR,
AND DVD PLAYER AND DISC

CUBANS, MILLED SUGAR CANE,
BLACK AND WHITE MONITOR,
AND DVD PLAYER AND DISC

DECAPITATED LAMB, ROPE, WATER,
SALT, AND CUBAN SOIL

LAWYER, NOTARY PUBLIC,
PAYMENT FOR SERVICES,
AND LEGAL AGREEMENT

STAGE, PODIUM, MICROPHONE,
LOUDSPEAKERS, CURTAIN,
TWO PEOPLE IN MILITARY FATIGUES,
DOVE, AUDIENCE, AND TWO HUNDRED
DISPOSABLE CAMERAS

TABLE, CHAIRS, MICROPHONE,
SOUND SYSTEM, GUN, AND BULLETS

PAINTED WHITE SPACE, TWO SOVIET
SPEAKERS FROM THE 1970S, SECURITY
GUARD, EGG CARTON, WOOD STAGE,
SIXTEEN SUBWOOFERS, DISCONNECTED
MICROPHONE, THREE UNFINISHED SHEET
ROCK WALLS, AND ELECTRIC BULB

NEWSPAPER WITHOUT A NAME,
DATE OR NEWS, POLITICAL SLOGANS
USED BY THE CUBAN REVOLUTION,
REPRODUCTION OF POSTERS
OF THE SLOGANS, RED INK, BLACK INK,
AND NEWSPRINT

CONTENTS

. . .

ACKNOWLEDGEMENTS

The history of performance art as a tool of political critique and a catalyst for social change remains largely unwritten. When the story is finally told, the work of Tania Bruguera should figure prominently in the account of pivotal recent developments. For the last two decades, she has devised well theorized, intellectually and emotionally compelling performative strategies to both describe and demonstrate, as she explains, "the subtlety and seductiveness of power, and our own participation in its processes"—the constellation of issues at the very heart of all collective human struggles.

It is a privilege to offer the first comprehensive exhibition and publication surveying Tania Bruguera's art and ideas, and we are most grateful to her for the opportunity; as well, for the extraordinary spirit of collegiality she brought to the collaborative process. Helaine Posner, the Neuberger Museum of Art's chief curator and deputy director for curatorial affairs, long an advocate for the critical, interdisciplinary art of our time, brought the full measure of her intellectual and curatorial gifts to the organization and administration of this complex exhibition and her rhetorical skills to this exemplary publication, and we thank her. Roy R. Neuberger, founding patron of the Neuberger Museum of Art and, at age 106, still a vocal advocate for younger artists, made both the exhibition and catalogue possible through his substantial support of a new annual exhibition prize that bears his name. As always, we thank him for his visionary leadership.

We want to acknowledge our guest authors—Carrie Lambert-Beatty and Gerardo Mosquera—who have made groundbreaking contributions to the scholarship on Tania Bruguera and her work. Nicole Bass, research assistant, and Marilyn Volkman, studio assistant, made central contributions to the realization of the exhibition and its catalogue. The good people at Charta, in particular Francesca Sorace, editorial director, and Giuseppe Liverani, publisher, made the publication process a pleasure.

Many members of the Neuberger Museum of Art staff and Purchase College community played significant roles in the implementation of this project. We would like to thank Damian Fernandez, Provost, who offered invaluable strategic advice; professors Lenora Champagne and Kate Gilmore, who, along with their students, enthusiastically participated in the recreation of Tania Bruguera's most challenging performance pieces; David Bogosian, chief preparator, and Jose Smith, preparator, for bringing the installation to life; Patrice Giasson, Alex Gordon Curator for Art of the Americas, whose translation and editorial assistance enriched the catalogue; and Eleanor Brackbill, head of museum education, and Lauren Piccolo, education assistant, who brought fresh perspectives to the planning of the elaborate public programs that accompany the exhibition.

Thom Collins, Director, Neuberger Museum of Art

INTRODUCTION

. . .

HELAINE POSNER

Tania Bruguera's work examines fundamental questions of power and vulnerability in relation to the personal, political, and collective body. An interdisciplinary artist working in the ephemeral, experiential forms of performance and installation, she creates a space where art, politics, and life converge. Bruguera was born, raised, and educated in Cuba where she began her career as an artist before relocating to the United States about a decade ago. An extensive traveler, she currently lives and works in three diverse cities: Chicago, Paris, and Havana. The broad social and historic perspective she brings to her work is rooted in personal experience and forms the basis for her socially responsible or useful art. Bruguera's work explores urgent issues, such as exile, displacement, and instability; and individual and collective responses to them, from submission, fear, and endurance to the hope for survival and the possibility of self-expression.

Bruguera began her narrative of the body by appropriating the work of another Cuban artist exiled from her homeland in 1960 at age twelve. *Tribute to Ana Mendieta* (1985–1996), Bruguera's graduate thesis at the Instituto Superior de Arte in Havana, is a conceptual performance project in which the younger artist reenacted Mendieta's signature *Silueta Series* (1973–1980), a group of works wherein she placed her naked body, or its outline or silhouette, into the landscape. Recreating Mendieta's mystical, ritualistic, corporal performances had great impact on Bruguera, deeply influencing her later work and prompting her to reconsider the meaning of Cuban identity. Her "reanimation" of Mendieta's earth/body art over the next several years also was a significant cultural act, one that restored Mendieta to the Cuban collective consciousness and posthumously fulfilled that artist's fervent desire for return.[1] For Bruguera and her generation, many of whom left the island in the early 1990s due to strong political and economic pressure, the decision to stay or go and its consequences was the central dilemma. As Bruguera remarked: "This made me reflect upon whether being Cuban meant solely living here, or whether it signified a condition beyond borders," and for many years migration and its effects were the primary subject of her work.[2]

In the late 1990s, Bruguera turned from embodying Mendieta to the creation of a few highly visceral, metaphorical performances that comment on the history of the Cuban people and typically feature the artist performing demanding rituals in the nude. Her physical and psychological feats of endurance recall the work of both Mendieta and pioneering performance artist Marina Abramović. One of the most striking and intense is *The Burden of Guilt* (1997–1999), a work based on the historic tale of collective suicide of indigenous Cubans during the Spanish occupation. According to legend, the native people, unable to resist the superior force of the invaders, decided to eat dirt until they died in a final act of rebellion. But as they consumed their ancestral land and its heritage, they also destroyed themselves. In her performance Bruguera ritualistically repeated this solemn gesture, rolling dirt mixed with salt water, symbolizing tears, into small balls and slowly ingesting them. She appeared naked with the carcass of a slaughtered lamb hung from her neck like a gaping wound. Both the lamb carcass and the artist's body were symbols of sacrifice.

By eating dirt, the native Cubans defied their conquerors with the only weapon at their disposal: passive resistance. However, their passivity was also a source of guilt as they silently succumbed to the will of the oppressor. To this day the popular Spanish expression *comer tierra*, or to eat dirt, means to experience very difficult times. While representing an historic event, *The Burden of Guilt* also has resonance in contemporary Cuba where acts of rebellion remain dangerous and submission or obedience, though shameful, may also be the surest means of survival. In this performance, Bruguera used her body to create an iconic image, one that captures the ongoing social and political reality of the Cuban experience in which the utopian promise is constantly undermined by the bitter facts of daily life. In a related work, *The Body of Silence* (1997–1998), the naked artist huddled in the corner of box lined with raw lamb meat making corrections in an official Cuban history textbook. Seized by a fear of the consequences, she began licking off her scribbling in an abortive attempt at self-censorship, ultimately tearing up and consuming the pages of the rewritten national narrative.

Bruguera has eloquently spoken of her choice of performance as a medium. She says:

> I was looking for a less passive way to engage with the audience, a way in which they would also feel involved . . . I was very attracted to the idea of art as something ephemeral; as an experience, as something one lived through . . . as an agent for social change . . . Not only did performance provide a more intense experience for me in the creation of the work, but I think it was also a way of sharing with the audience with greater access and participation on their part . . . When I began to perform, I thought I found the medium with the solution to all my restlessness. It struck me as an ideal medium, ephemeral but with great impact . . . In the end, the work is remembered as images in our memory, impressions, and also as stories. The work functions as commentary. As such, I think performance can work like any other medium.[3]

In 2000, Bruguera was invited to participate in the 7th Havana Biennial where she created the first of four related performances/installations to be presented internationally over the following ten years. In an ambitious departure from her earlier performance work, the artist constructed a conceptually powerful, physically enveloping environment that engaged the audience as it alerted their senses of sight, sound, smell, and touch. The artist, however, was no longer present, as the focus of her work shifted from the personal to the social or political body. *Untitled (Havana, 2000)* took place in a darkened tunnel at La Fortaleza de la Cabaña, a former military fortress, where generations of Cubans had been imprisoned. An uneasy mood prevailed as viewers traipsed through the dark and stumbled upon layers of rotting *bagazo*, or sugarcane husks, covering the prison floor and emitting the noxious stench of fermentation. As

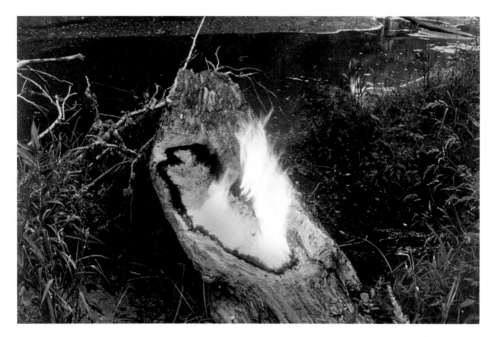

Ana Mendieta, *Untitled (Silueta Series, Iowa)*, 1977
Lifetime color photograph
13 1/4 x 20 inches
Des Moines Art Center
© The Estate of Ana Mendieta Collection
Courtesy Galerie Lelong, New York

visitors anxiously made their way through the dark and over the thick, fetid detritus, they spotted a blue light in the distance. It was a video monitor displaying silent archival footage of Fidel Castro in his prime, giving a well-known speech, swimming in the ocean, and waving to the crowd, punctuated at one-minute intervals by the image of the leader bearing his chest. Unexpectedly, the shadowy figures of four naked men emerged from the darkness, each performing a single, repetitive gesture. One rubbed his body as if to remove the smell of the sugarcane, another used his fingers to pry open his mouth, a third wiped his face with his forearm, and the last slowly bowed. On exiting the tunnel the visitor was blinded by the bright Caribbean sun.

In this work, Bruguera offered a subtle, yet penetrating critique of Cuban life since the so-called triumph of the revolution. In hindsight, she suggests, the glorious past is revealed to have been nothing more than a series of "repeated rituals and empty gestures," and the people so seduced by power that they have become blind to what is happening all around them.[4] Essentially, *Untitled (Havana, 2000)* was a call for greater political awareness and responsibil-

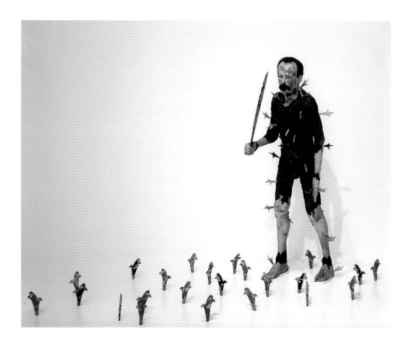

Juan Francisco Elso, *Por América* (*For America [José Marti]*), 1986
Wood, plaster, earth, pigment, synthetic hair, and glass eyes
56 3/4 x 17 1/4 x 18 1/4 inches (entire work: dimensions variable)
Hirshhorn Museum and Sculpture Garden, Smithsonian Institution,
Joseph H. Hirshhorn Purchase Fund, 1998
Photograph by Lee Stalsworth

ity on the part of the Cuban people presented in the context of an international art event. The impact of this message was such that the installation was officially closed after one day.

Two years later, Bruguera had the opportunity to test whether her work, which so far had been based in her Cuban experience, would translate to a major international setting when she was asked to create an installation for Documenta 11 in Kassel, Germany. *Untitled (Kassel, 2002)* returned to the theme of social responsibility within a vastly different yet equally charged geo-political site. Once again, the artist used light and darkness to examine such concerns as power and vulnerability, and historic memory versus cultural amnesia; or the question of what we as a society choose to acknowledge and act upon and what we choose to ignore.

All elements of *Untitled (Kassel, 2002)* conspired to create a sense of vulnerability in the viewer, prompting memories of wartime and, given the location, World War II. A row of 750-watt lights was strung on a trestle above the entrance to the installation, assaulting the eyes of the viewer as if under interrogation. The metallic clicking sound of a person on patrol loading and unloading a gun was heard overhead. At first one did not know whether this sound was

live or recorded, but it gradually became clear that real human beings were watching and, in theory, threatening one's life. Suddenly the bright lights went out, the sound ceased and, for a few moments, the darkened space was dimly lit by a projection displaying the names of one hundred locations across the globe where political massacres have occurred since the end of World War II, some resulting in enormous casualties. With the city of Kassel, once the site of a large ammunition factory and a target of severe bombing during the war, as context, Bruguera encouraged the audience to recognize the global reach of political violence as personal threat by placing them directly in the line of fire.

Bruguera continued to tackle hot topics in her work but in a more conceptually and formally cool manner. In conversation, she described this shift in approach as "more Felix Gonzales-Torres than Ana Mendieta," citing another Cuban-born artist whose work combined the impulses of conceptual and minimal art with social themes to create formally restrained yet emotionally poignant installations. Essentially, her work became less visceral and more theoretical. The untitled series also marked another important change in her practice as she moved from presenting herself as performer to engaging the audience as active participants. The third in the artist's series of performances/installations, called *Untitled (Moscow, 2007)* or *Trust Workshop*, was a year-long project presented as part of the 2nd Moscow Biennale of Contemporary Art. In this work, Bruguera set up a situation in which she invited Russian citizens to share their lingering distrust of Soviet officials with the workshop coordinator, a former KGB agent. They told personal stories of misfortune or political persecution to the agent, who used specialized skills developed in Cold War training to redress the painful psychological repercussions of the era and to begin to restore trust. The primary goal of the workshop was to heal the generational and ideological gaps that separate the Russian people as their country enters a new social, political, and economic era.

Bruguera's performance/installation took the form of a photography studio in which visitors were invited to pose for their portraits beneath a framed photograph of Felix Dzerzhinsky, founder of the Bolshevik secret police. The anxious participants and their families were asked to choose between having their picture taken with a live eagle or with a monkey. According to the artist, the eagle, poised on the subject's shoulder, was intended to signify history, power, and the establishment, while the monkey, dressed in children's clothing and propped on one's lap, represented youth, pleasure, and the rise of capitalism in the new Russia. The choice was clearly symbolic: either one could hold on to the old ideology or cast off the vestiges of a repressive regime and move forward.

In the untitled series the artist made a significant transition from exploring power relations within her own country to reflecting more broadly on the ways in which different social or political entities relate to their histories and issues of moral conscience and express their hopes and fears. The series is completed by *Untitled (Bogotá, 2009)* and *Untitled (Palestine,*

2009), currently in-progress, which will be presented at the 3rd Riwaq Biennale and will examine some of the complexities of that contested site.

Teaching is an important part of Bruguera's professional life and is closely tied to her artistic practice. She is an Assistant Professor in the Department of Fine Arts at the University of Chicago and, until recently, she ran an art school called the Cátedra Arte de Conducta under the auspices of the Instituto Superior de Arte in Havana, which also functioned as a conceptual work of art. The goal of this school was to teach a younger generation of Cubans to develop ways to make art that can play an active role in society, using human behavior as an artistic material. Bruguera describes Arte de Conducta, or behavior art, as a counterpoint to performance art. Rather than use the body to create signature images as in performance, in Arte de Conducta one constructs situations that compel the audience to examine their behavior and to respond, not simply observe. In Bruguera's recent Arte de Conducta actions, she employed various strategies of power, from propaganda and crowd control to more subtle forms such as an academic lecture and the granting of free speech, to create a series of lived experiences that prompted collective reactions.

A stunning example of Bruguera's new work took place on the bridge of Turbine Hall at Tate Modern in London where museum-goers were confronted by two uniformed policemen on horseback practicing a full range of crowd control techniques. Visitors responded to these imposing figures as they would in real life, yielding to the officers' verbal instructions and to the animals' commanding physical presence. The action did not appear to be an art event and the audience reacted predictably to this demonstration of power. *Tatlin's Whisper #5* (2008) succeeded in making viewers more aware of their reflexive passivity in the face of authority and encouraged them to reexamine their conditioned responses.

Bruguera created the sixth in this series of actions designed, in her words, to "reproduce images familiar from the media as direct and participatory experiences" for the 10th Havana Biennial.[5] In *Tatlin's Whisper #6 (Havana Version)* (2009), she constructed a raised podium in the central courtyard of the Wifredo Lam Center, distributed 200 disposable cameras, and invited audience members to step up to the microphone and exercise freedom of speech for one minute each. This call tapped into deep emotions in a country that has repressed free speech for nearly fifty years and where the consequences of self-expression can be grave. During the performance, each speaker was flanked by two individuals dressed in military fatigues who placed a white dove on his or her shoulder, evoking the moment in 1959 when a dove alighted on Fidel Castro during a famous speech.

A variety of anti- and some pro-revolutionary voices were heard, a woman wept, and a young man said he never felt so free. Nearly forty people spoke in all. Their calls for freedom echoed for an hour, after which time the artist ended the performance by stepping up to the podium and thanking the Cuban people. By providing a public platform for the audience to speak out against censorship, to call for liberty and democracy, or to state whatever was on their mind,

the artist tested the limits of acceptable behavior under a totalitarian regime in an attempt to create a socially useful forum. In the following days, the event was officially renounced by the Biennial's organizing committee, but by then the people had spoken and footage of their statements received over 47,000 hits on YouTube.

In 2006, Bruguera signed a notarized agreement with artist J. Castro called *L'accord de Marseille* stating that when one of them dies, the other will present a performance using his or her dead body. The work may take several forms including a collaboration, a legal agreement, a public question and answer session, an object to be displayed in a museum, and the performance itself. It also poses a number of important questions, first and foremost: "What is art?" Like much of Bruguera's work, the accord blurs the boundaries between art and life, here in an extreme way. *L'accord de Marseille* also tests another limit: that of the personal body as repository of art and site of social critique, converting the artist's body into a legal body within the public sphere.

Tania Bruguera's art traces a remarkable course that begins with her body and personal experience, goes on to explore the greater political and communal body, and encourages us to consider individual responsibility within a global context. Her journey has taken her from the Cuban-themed body performances of the 1990s, through a series of major performances/installations that look at the social and political implications of such charged international sites as Havana, Kassel, Moscow, and Palestine to a new form called Arte de Conducta or behavior art, in which she stages live events meant to activate and engage viewer response. Throughout her work, she has used her Cuban experience of cultural displacement and marginality as a prism through which to examine the mainstream and the individuals' often difficult relationship to power. She credits her teacher, the acclaimed Cuban artist Juan Francisco Elso Padilla (1956–1988), with providing inspiration for her work, stating:

> I took from him the idea that art had to be completely linked with life—and not a fiction or a virtual reality, but as alive as possible. My art has to have a real function for myself, to heal my problems or to help other people to reflect and improve . . .[6]

For Bruguera, art serves as testimony, as social commitment, and as emotional experience, and is, foremost, ethical at its core.

1. Gerardo Mosquera, "Reanimating Ana Mendieta," *Poliéster*, 4, Winter 1995, p. 52. I am grateful to Gerardo Mosquera for his insight into the impact of Bruguera's reenactment of Mendieta's *Silueta Series* in Cuba.

2. Euridice Arratia, "Cityscape Havana," *Flash Art* 32, January/February 1999, p. 48.

3. "Tania Bruguera in Conversation with Octavio Zaya," in *Cuba: Maps of Desire*. Vienna: Kunsthalle Wien, 1999, pp. 245, 249.

4. Nico Israel, "VII Bienal de la Habana," *Artforum* 39, February 2001, p. 148.

5. In conversation with the artist on September 15, 2009.

6. Johannes Birringer, "Art in America (The Dream): A Conversation with Tania Bruguera," *Performance Research* 3, Spring 1998, p. 26.

CUBA IN TANIA BRUGUERA'S WORK: THE BODY IS THE SOCIAL BODY

...

GERARDO MOSQUERA

Two of the most impressive and moving experiences I ever had before works of art occurred when aesthetic and social components empowered each other. Both factors were so well integrated that these works could be considered either art or social actions. Thinking about this today makes me even more aware that a key reason for my attraction to art is its manifold potential for dealing with things beyond itself in a unique, profound manner.

Both works were performances. Not that I have any particular inclination towards this form, but only the qualities of performance art could have carried the impact of these specific works: action and experience were the means of shaking things up. These extraordinary performances, which did not occur at main art centers but in crumbling Old Havana, addressed critical cultural, social, and political issues in Cuba. What's more, they took an active part in them. The actions both happened during the Havana Biennial, one as an alternative, independent event, the other as part of the Biennial's parallel program. The first one took place in 1997, the second in 2008. Both were by Tania Bruguera. In between them lies a decade of intense artistic actions that has credited Bruguera as a major international figure in performance art.

The 1997 performance was held on a late afternoon in the artist's home, located at a turbulent spot in Old Havana. Unfortunately, the only available visual documentation of this action are artist Pedro Abascal's photos. There is also the recording of a reenactment staged by Bruguera. The work is very difficult to describe because a crucial aspect was the setting's complex environment and the ambiance that the performance created around it. The artist opened a wide entrance, rarely in use, that directly connects her living room with a narrow street and a creepy bar right in front. In this way, her private space became part of the populated, intense street life. All the furniture was removed, and *Statistics* (1996–1998), an artwork consisting of a twelve foot high Cuban flag made out of human hair—some of it coming from friends of the artist who lived in the country and others who had just gone into exile—was hung as the backdrop. The artist stood in front facing the street, dressed in white jumpers with an open lamb carcass hanging from her neck and two ceramic bowls before her. In a state of concentration, Bruguera took soil from the bigger bowl, moistened it in the smaller one containing fresh water with salt, made small balls of the dirt, and ate them.

Titled *The Burden of Guilt*, the action referred to a legend about native Cubans eating soil to commit suicide as a passive way to resist the Spanish conquistadores. Wearing a lamb carcass as a sort of dress was another reference to protection through submission. The performance also alluded to a Passover ritual, in which water with salt recalls the suffering and tears of the Jewish people enslaved in Egypt. More importantly, "to eat dirt" (*comer tierra*) is a Cuban expression that means to suffer strong hardship. The performance took place at an extremely critical period in Cuba, after the country's patron, the Soviet Union, collapsed, and in the midst of the Cuban regime's unwillingness to reinvent their politics in order to respond to new times. As a result, people in Cuba were "eating dirt."

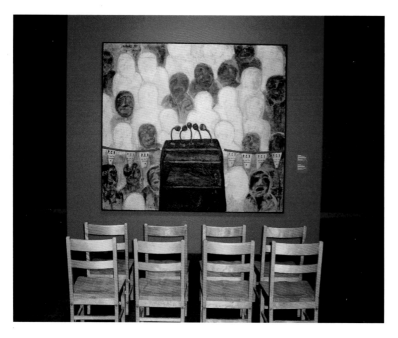

Antonia Eiriz, *Una tribuna para la paz democrática* (*A Tribune for Democratic Peace*), 1968
Oil and collage on canvas
86 1/2 x 98 1/2 inches
Museo Nacional de Bellas Artes, Havana
Photograph by Corina Matamoros

And yet, beyond all these references and other more intimate suggestions of guilt, sacrifice, and endurance, the gesture of this young Cuban woman eating Cuban dirt in Old Havana for forty-five minutes, introducing the Cuban soil, the Cuban land, into her organism at a critical time, feeding on it or poisoning herself with it, was so candid, so disarmingly immediate, heartbreaking, and poignantly rich in meanings and feelings that it was impossible to divide it from a living piece of reality. The artist's body was her own subjective body, but it was simultaneously ritualized into a social body.

A main signifier for this artistic experience was its setting. The space was packed with people from the Cuban art world and international visitors who were in Cuba for the Biennial, and also with neighbors, passers-by, children, and people attracted by such an unusual event, while customers in the bar watched from across the street. There was a constant, random flux of people walking around or staring inside for a while and then continuing on their way—even a dog entered the space and stayed close to the artist. The police arrived later. A dynamic, ever-changing mix of very diverse people looked, commented, tried to understand

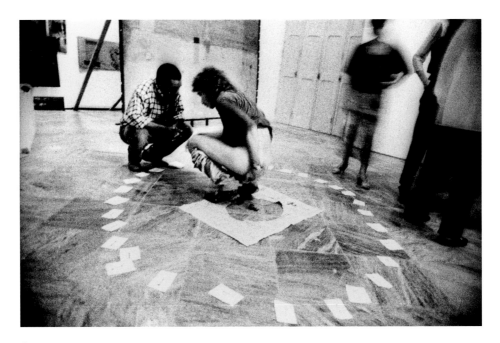

Ángel Delgado, *La esperanza es lo único que se está perdiendo* (*Hope Is the Only Thing that We Are Losing*), 1990
Unauthorized performance at the exhibition *El Objeto Esculturado* (*The Sculptured Object*)
Centro de Desarrollo de las Artes Visuales, Havana
Courtesy Cuban Performance Art of the 80s (Chronology)
Photograph by Adalberto Roque

what was going on—"She is saying that we all are eating soil!" a man retorted—sweated, agglomerated. The performance space actually became part of the street, in what could be considered a public artwork emanating from a private realm. The situation was vibrant and noisy, with people exclaiming out loud and the street sounds, from traffic to laughs, creating an intense atmosphere in which performance, audience, location, sounds, smells, and context were woven together.

Tatlin's Whisper #6 (Havana Version), the 2008 performance, was a participative action at the central courtyard of the Wifredo Lam Center (the institution that organizes the Havana Biennial). A stage with a podium, two microphones, and a huge golden-brown curtain as background were placed at one end. The set was reminiscent of the staple one used by Fidel Castro for his speeches. The microphones were connected to an amplifier with speakers, one of them at the building's entrance, pointing to the street. Two actors, a woman and a man dressed in Cuban military uniforms, stood at each side of the podium. The woman had a white dove in her hands. Admission to this event was free, but, in contrast to *The Burden*

of Guilt's mixed, spontaneous, more grassroots audience, the space was filled with people from the Cuban art world, mainly young artists, and with students, writers, and Cuban and international visitors to the Biennial. Two hundred disposable cameras were handed out to the public by Bruguera to document the event. Then people were summoned to speak their minds on the podium for one minute. In other art contexts this would not have had any special relevance. In Cuba, it was an historic event: for the first time in half a century a free public tribune was allowed for people to express their ideas. Thus, the artwork managed to use art's more permissive field to create a space for freedom in a totalitarian context. The performance was art due to its symbolic structure, and because it was labeled as such and was taking place in an art framework. Simultaneously, it was a radical political action in Cuba. *Tatlin's Whisper #6 (Havana Version)* took Irit Rogoff's productive notion of "the exhibition as occasion"[1] to the extreme, while uniting art with the real, as in *The Burden of Guilt*. In her lecture-performance *On Politics*, Bruguera has pointed out that "art is a safe platform from which to have a dialogue about political ideas and even try new political structures."[2]

The first person to take the podium was Guadalupe Álvarez, a Cuban critic and professor who played an instrumental role in the so-called New Cuban Art by supporting and discussing it during the 1990s, while introducing contemporary theory at Havana's University and Art Institute, for which she was given so much trouble that she was forced to resign. She finally left the country for Ecuador, where she still lives today. The military-looking actress put the white dove on Álvarez's shoulder, in an obvious allusion to the emblematic image of dove-on-the-shoulder Castro delivering his first speech in 1959 in Havana after the revolutionary victory against dictator Fulgencio Batista. Meanwhile, the actor kept control of time on his watch. To general surprise, all Álvarez did at the podium was cry, a painful, awesome statement given the performance's references, the context, and her personal story.

Many diverse speakers went to the podium, received the dove on their shoulders, and, if they exceeded the one-minute limit, were violently taken away by the "military" actor. Among the initial speakers was Yoanni Sánchez, a famous young Cuban blogger, officially tagged as an active political dissident, who advocated for free Internet access in the country. The performance snowballed into an unexpected, spontaneous political rally. Statements ranged from calls for free elections to shouts of "Freedom! Freedom!" Participants in the audience became outspoken while, at the same time, concern with repression saturated the environment with a tense, fearful climate. Perhaps the statement that epitomized the whole event was that by a woman who said that she wished that one day freedom of speech in Cuba would not have to be a performance. Indeed, Bruguera's art work managed to profit from art's privileges (aura, tolerance, international attention) in order to make the impossible possible in Cuba: a free public tribune. Art created the opportunity for political action, opening a space for freedom.

As one can see, an event like this is a major, striking issue in Cuba. The next day, the 10th Havana Biennial Organization Committee published an official proclamation condemning the performance in the most authoritarian terms and language. This declaration completed the work's semantic circle, showing its political impact. But, as Bruguera has also stated in *On Politics*, artists' privileged position can only exist if people with real access to power allow it.[3] Why was a project like *Tatlin's Whisper #6 (Havana Version)* allowed? In my opinion, the Biennial organizers, the State Security, and other implicated officials miscalculated the possibility of people reacting so strongly to the occasion facilitated by the performance. They probably thought that self-censorship as a result of terror would make people afraid to take the risk of speaking out and, in the case of someone going beyond the limits, his action would take place within a reduced art context. The authorities possibly considered also that the audience would chiefly consist of international visitors and that some light critical expressions would serve to project a good image. The prospect of no one daring to speak out was also considered by the artist, who conceived her piece to work in a different way in case the public remained silent. She thought of the empty podium as a "monument to the void," a monument to Castro's absence after fifty years of being a daily, overwhelming presence for Cubans.[4] Also, an empty podium with two microphones was famously painted in 1968 by Antonia Eiriz, a leading Cuban artist who was censored and who reacted by renouncing art for the rest of her life in a dramatic statement about repression and freedom. The empty podium would clearly refer to that emblematic Cuban painting and the story behind it.

But that did not happen, and what took the authorities by surprise and upset them the most, as can be deduced from the official declaration's content, was the presence and participation in the performance of persons officially labeled as dissidents. Since the mid-1980s, many of the artists in Cuba have played a critical role by frequently discussing the country's crisis in a serious and complex mode. Most of these critical artists, including Bruguera herself, can be considered dissidents. However, until *Tatlin's Whisper #6 (Havana Version)*, there was a split in Cuba between critical artists and opponents to the regime who by engaging in direct, peaceful political resistance are marked as dissidents and "counterrevolutionaries" and treated harshly. As in Sánchez's case, their actions usually consist of criticizing and denouncing the situation in Cuba—very similar to what artists do. However, the latter are not classified as dissidents and enjoy tolerance by virtue of being artists—many of them are well known internationally—and thanks to the indirect, metaphoric character of art's political criticism. Although a few artists like José Angel Vincench and others have included references to Cuban political dissidents in their works, Bruguera mixed both sectors for the first time, bringing them together to perform an artwork that was both artistic construction and real political action, even in the very character of the participants involved.

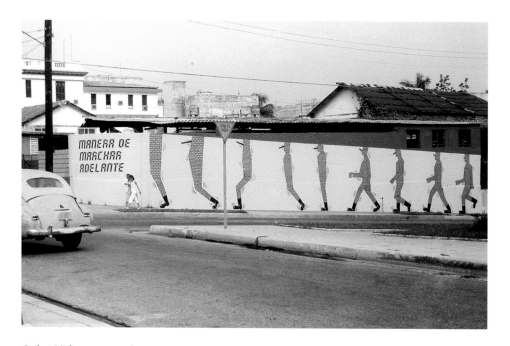

Carlos Cárdenas, *Manera de marchar adelante* (*Way of Marching Ahead*), 1988
Public mural at G Avenue and 15th Street, Vedado, Havana (destroyed)
Photograph by Gerardo Mosquera

Now, reading my efforts to describe these two performances and, even more, to convey the experience that many of us in the audience went through, I realize the difficulty of "reading" them because, as Judith Butler would say, these performances "effected realness": "the impossibility of reading means that the artifice works, the approximation of realness appears to be achieved, the body performing and the ideal performed appear indistinguishable."[5] Such fusion, which comes from the Situationist notion of suppression and realization of art as two inseparable conditions for surpassing it,[6] made these two performances extraordinary occurrences that achieved what Bruguera has stated to be her main goal: to work with reality, not with representation. "I want people not to look at it [the artwork] but to be in it, sometimes even without knowing it is art."[7] Being *in* the art makes it difficult to read, but not to remember as a memory of something that becomes part of your own life experience. The artist has also said that she wants her art to be "an experienced emotion," and its documentation not to be photos or videos, but a "lived memory"—an art to be remembered more than to be seen.[8]
Political content and action have been intrinsic to Bruguera's art since its inception. She has

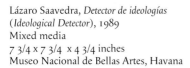

Lázaro Saavedra, *Detector de ideologías*
(*Ideological Detector*), 1989
Mixed media
7 3/4 x 7 3/4 x 4 3/4 inches
Museo Nacional de Bellas Artes, Havana

Lázaro Saavedra, *El arte, un arma de lucha*
(*Art, a Weapon for Struggle*), 1988
Painting
39 1/4 x 23 1/2 inches
Museo Nacional de Bellas Artes, Havana

suffered harsh censorship, as with her untitled performance at the 7th Havana Biennial in 2000, which lasted only one day, or, more dramatically, with *Memory of the Postwar I and II*, the independent art and culture newspaper that she published in Havana in 1993–1994 with contributions by Cuban and foreign artists and authors.[9] In a country without free press, to publish an underground newspaper with critical content was and is a radical action to undertake. In a way, it was an endurance performance due to the official hostility, the practical difficulties, and the lack of resources to make a black market publication in Cuba. The publication gave painful troubles to the artist and was banned and confiscated after its second issue, while some Cubans who participated in the project were detained or fired. *Memory of the Postwar*, which the artist considers part of her *arte de conducta* (behavior art), can also be seen as cultural activism. However, for Bruguera, real activism cannot be separated from her artistic practice. In these performative actions the body that performs "is the social body," as the artist has stated.[10] The other way around, in performances like *The Burden of Guilt*, it is her performing body that impersonates a social body.

Bruguera is part of the critical orientation typical of Cuban arts from the mid-1980s until today. Beyond its broad international diffusion and impact, her work has to be understood from this context. In an unexpected substitution, the lack of civil society, independent media, and spaces for discussion in Cuba have been partially compensated by the arts, which—in a tendency that began in the visual arts—have operated as one of the very few critical arenas tolerated up to certain limits. In Cuba the formula is: total governmental control over the media, restricted freedom for the arts. Of course, this responds to the arts' minority appeal together with the strong pressure from the intelligentsia, the international solidarity that it enjoys, and the regime's strategy of allowing some criticism that can function as an escape valve. In any case, Cuba has built a critical culture that has analyzed the country's predicament in depth, from an internalized position, addressing the collapse of its utopian project, the failure of the social hopes that had been so messianically instilled, and the nation's critical situation, among other urgent and relevant issues. Bruguera's cultural and political activism comes from that context; she is part of a general movement in Cuban culture.

The inclination towards political dissent in Cuban art was introduced by a new generation of artists who, in the 1980s, transformed the official modernist, ideology-centered, nationalistic, conservative status quo of the previous decade, freeing the scene and renewing the country's culture. The 1980s are increasingly being considered the Golden Age of Cuban art, to the point of becoming a myth. It was a period of very intense, transformative artistic energy, and also of conceptual discussion, social criticism, and openness to international trends. An art of ideas prevailed, with neo-conceptual and postmodern slants. Performance, set off in the late 1970s by Leandro Soto, was significant at the time, to the point that Ángel Delgado spent six months in jail for defecating at an opening, as part of an unannounced performance.[11] The Havana Biennial was also launched in 1984, establishing Havana as the first space where contemporary art from Africa, Asia, the Caribbean, Latin America, and the Middle East was exhibited and discussed, pioneering the international art circulation that we enjoy today and creating a global space for encounter and exchange.

Bruguera was part of the continuation of this artistic process—which has been called the New Cuban Art[12]—in the 1990s, when she came into her own as an artist. She has acknowledged that Cuban artists from the 1980s such as Carlos Cárdenas, Flavio Garciandía, Glexis Novoa, Lázaro Saavedra, José Ángel Toirac, and the Arte Calle Group have been "the real and most important influence" in her work.[13] It is telling that those she mentioned were some of the most confrontational and politically oriented artists in the 1980s, and that she is neither referring to the impact of an individual figure on her nor to a formal or poetical intertextuality, but rather to a general spirit of connecting art with society in a real and critical manner. Another key inspiration was Ana Mendieta, who visited Cuba several times during

the 1980s and was very close with and influential to the new Cuban artists.

Mendieta's effect on Bruguera was preceded by her training with Juan Francisco Elso at the Elementary School of Art in Havana when she was very young. This remarkable artist, who passed away in 1988 at the age of thirty-two, was paradigmatic of the new Cuban artists' mystical and "anthropological" inclination[14] in the first half of the 1980s (José Bedia, Ricardo Brey, Rubén Torres Llorca). They made installations that were often instruments of an existential experience, using methodologies related to Afro-Cuban religions, and stimulated the symbolic dimensions of the materials. These methodologies helped them to codify artistic-philosophical discourses of a transcendental telluric nature, using invented rituals and carefully structured symbolism. The connection with Mendieta's silhouettes and body-earth works is obvious; there was actually a meaningful intertextuality and exchange between her and these artists. The leading artists who emerged during the second half of the 1980s— most of the list that Bruguera has mentioned as her main influence—followed an opposing social and critical approach.

Elso's teaching was a projection of his art, and he looked to activate a creative personal experience among his disciples, akin to the work just described. Young Bruguera was part of this general feeling, and her admiration for Mendieta prompted her to re-enact the Cuban-American's performances and earth-body works, to carry out others that Mendieta left sketched, and to invent other ones. These appropriations and re-enactments were an homage, a way to make Mendieta known to younger artists in Cuba who at the time ignored her, but also, and more significantly, they were a vicarious procedure to bring Mendieta back to her homeland, to Cuban culture, and to life.[15] What RoseLee Goldberg called "Bruguera's re-performances," which she considered an "entirely new approach to performance history,"[16] were artistic transubstantiations born out of the ritualistic, mystical approach to art typical of Elso and other Cuban artists in the early 1980s. Even more, they involved the act of possession, the main liturgical moment of Afro-Cuban religions. Possession, typical of Sub-Saharan traditional religions, consists of a deity or a spirit taking control of the worshipper's body, usually during a ritual dance, to come to this world and express himself. Bruguera's re-performances were artistic-religious possessions, or were loaded with their undertones. At the time when she made these appropriations, Bruguera did not know Mendieta's early performances, which showed a socially critical feminism more related to Bruguera's later work. When she discovered them in Mendieta's retrospective at the Whitney Museum, she expressed her preference for these pieces over the ones that she had re-enacted.[17] Bruguera thus evolved from a mystical poetics to social action, the reverse of Mendieta's path.

Two crucial events happened in Cuba at the turn of the decade that conditioned the art scene in the 1990s. One was a repressive backlash as a result of political art going beyond the de-

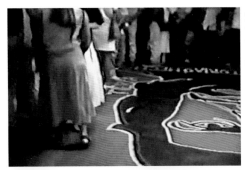

Arte Calle
Performance at the exhibition
Nueve alquimistas y un ciego,
(Nine Alchemists and A Blind Man), 1988
Courtesy of Ofill Echevaría

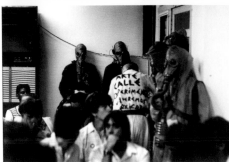

Arte Calle
No queremos intoxicarnos
(*We Do Not Want To Be Intoxicated*), 1988
Performance at the Unión Nacional
de Escritores y Artistas de Cuba,
(National Union of Cuban Writers and Artists),
Havana
Courtesy Cuban Performance Art of the 80s
(Chronology)
Photograph by Rafael

gree of criticism that the government was able to tolerate. The other was the artists of the 1980s' massive diaspora motivated by this new situation and the legal restrictions that were hampering their international movement. Critical art did not disappear, but the generation of the 1990s, to which Bruguera belongs, was, in general terms, less poignant in this aspect. Bruguera was trans-generational: she took the critical political spirit of the previous generation that had left the country and developed it within the new one. Although, I insist, there was plenty of political art in the 1990s in Cuba, Bruguera was the only artist of that generation who systematically followed a social line throughout her entire career. Back in 1995, I wrote: "Bruguera is always striving to unite artistic practice with life. Sometimes the works make social commentaries, but they are always derived from a personal perspective, an intimate feeling . . . The social dimension of her work is not only the subject, it is also concrete action."[18] This early commitment has shaped her work's very nature until today. Therefore, focus on social issues, *arte de conducta*, art that commits real actions, collective participation and creation by the audience, Bruguera's understanding of authorship, and other crucial el-

ements of her work were widely developed in international terms by the artist, departing from Cuba's spirit and its seeds during the 1980s.

Bruguera shares her time among Chicago (where she teaches), Cuba, and the greater world. She has been included in the top biennials and enjoys broad international demand. Hence, the great amount of energy and dedication that she devotes to a place like Cuba is admirable—not usually the case with artists from the "peripheries" who reach considerable international stature. The Cátedra Arte de Conducta (Center for Behavior Art Studies), an ambitious independent workshop program on "studies in political art"[19] for young artists in Havana that was held for seven years with the contribution of leading Cuban and international artists, curators, and scholars, has been Bruguera's main project since it opened in January 2003. Its purpose was to create "an alternative training space focused in the discussion and analysis of social conduct and the understanding of art as a way of establishing a dialogue with reality and the civic current situation."[20] The Cátedra was the only training program on performance art in Latin America ever. It played a major artistic and educational role in Cuba by giving young artists the opportunity to work and study for free with figures ranging from Anri Sala to Nicolas Bourriaud, Boris Groys to Thomas Hirschhorn, Dora Garcia to Patty Chang, and dozens more. Conceived by Bruguera as a response to the Instituto Superior de Arte's decadence and some artists' use of class advantage, she managed to establish and run an alternative, well-focused, top quality space. Was the Cátedra art or a very effective, much needed, and well-targeted social, educational, and pedagogical action? For Bruguera it was Arte de Conducta, and as such it was shown at the last Kwangju Biennial.

Actually, the question is irrelevant since, apart from blurring its frontiers and breaking away from given morphologies and classifications, a considerable part of contemporary art is tied to other activities, which sometimes involve social action and personal relations, or it constitutes a diversified process that enters and exits the artistic sphere in certain moments and spaces in order to enter and exit others. Certainly there have been many efforts to avoid the self-restriction of art and to grant it more cultural and political significance without diminishing the complexity of its discourse. All of these strategies of connecting art with political action and social activism, education, sociology, psychology, technology, research, personal interrelations, or shamanism are plausible, although they often have not been able to go beyond representation. In many cases the works suffer the fatalism of art's fetishization: they tend to be legitimized in restricted, traditional auratic spaces. Worse, sometimes when artists go out to the social environment it is just to try a particular way of making the work, whose predetermined final destination is the showroom, the publication, or the web, after having been documented for this purpose. Documentation is frequently the super-objective that operates from the project's very moment of conception, and the work is only the process that leads up to it. Too many times, actual social implications and effectiveness fall to

the background, so the works are generally judged by their artistic-conceptual excellence rather than their real impact on the social context where they unravel, an impact that is not measured beyond the anecdote. The structure of the artistic field—highly specialized and intellectualized—based on exhibitions, publications, in-the-know elites, collectionism, and the luxury market, has not been so radically defied as it seems.[21]

By intending art to achieve real and necessary social and political actions, Bruguera tries to go beyond these mannerisms. She has also been reluctant to exhibit and sell documentation about her performances and prefers to sell the right to re-enact them, an action that might introduce changes to the original work according to the new situation in which it will happen. "What needs to be reproduced," she has stated, "is not the gesture, not the image that is the result of the gesture, but the implication of the gesture."[22] This idea corresponds with her notion of documentation as a living memory, an impression, a feeling that remains with you after participating in the performative experience. She has even executed this notion in her piece *46 Days, 46 Performances* (2002).

Interestingly, Bruguera is very far from being any sort of street artist or a social or political militant. She is as concerned with the social aspect of her work as she is with the legitimization of her career by the mainstream art world. She is as eager to participate in biennials or to have museum exhibitions as she is to devote herself to the Cátedra Arte de Conducta. In a way, she bridges both sides and makes them empower each other. This is true yet in practical terms: the Cátedra was possible because of her international connections, and at the same time, it gave Bruguera credentials before the art world. However, her Arte de Conducta is not usually artsy, while her more traditional performances and performance-installations always have a social content and frequently look for a social aim.

It might sound exaggerated to say that all of Bruguera's oeuvre is about Cuba. Naturally, the place where artists grow up, receive their education, and initiate their careers will remain a basic foundation from which their art will stem. But in Bruguera's case, on the one hand, a great deal of her work is about Cuba thematically, borrows from the island's culture and history, and has Cuba's problems as a target. On the other, when addressing non-Cuban subjects, it seems as if her works were conceived and shaped from feelings, positions, and poetics whose active base is the very complex and traumatic experience of the artist living the failure of utopia in Cuba and its predicaments. We recognize this even in works that can be seen as an indirect reaction to German history, like her untitled video-performance-installation for Documenta 11, or even in *Responsible for the Fate* (2004), in which such a reaction is very concrete and apparent.

Although Bruguera's work is performative rather than "participative," a basic component of it is to establish grounds for people to take part, interact, and yet more: to express themselves, to create and to undertake action. In the best cases, this generosity is more than an

artistic gesture: it satisfies, even if partially and temporally, actual needs, like freedom of speech or art education in Cuba. But Bruguera always does this in a confrontational way, to defy and provoke. There are even cases in which the audience to which she gives voice is also deceived, as in *Responsible for the Fate*, in order for the work to transmit a critical message about history and guilt. In *Tatlin's Whisper #5* (2008), the British mounted police harassed the audience using mass control techniques. Bruguera's work is both belligerent and generous. It stands in opposition to the harmonistic conception of the social that Claire Bishop has criticized in Bourriaud's relational aesthetics, pointing to a more confrontational understanding of human relations.[23]

1. Irit Rogoff, "The Implicated – A Model for the Curatorial?," opening lecture at the Rotterdam Dialogues.
The Curators, Witte de With, Rotterdam, March 5, 2009.
2. *Tania Bruguera*. Venice: La Biennale di Venezia, 2005, p. 155.
3. Ibid.
4. Tania Bruguera in conversation with the author in Havana and later through email exchange.
5. Judith Butler, "Gender is Burning. Questions of Appropriation and Subversion," in Zoya Kocur and Simon Leung (eds.), *Theory in Contemporary Art since 1985*. Malden, Oxford and Carlton: Blackwell Publishing, 2005, p. 172.
6. Guy Debord, *La Sociedad del Espectáculo*. Valencia: Pre-Textos, 2000, p. 158.
7. RoseLee Goldberg and Tania Bruguera, "Interview II," in *Tania Bruguera, Op. cit.*, p. 29.
8. Ibid., p. 27.
9. *Memory of the Postwar (Memoria de la Postguerra)* was reproduced in Ibid., pp. 62–104.
10. Ibid., p. 31.
11. Glexis Novoa has thoroughly collected information about performance in Cuba during the 1980s.
12. About this art see Luis Camnitzer, New Art of Cuba. Austin: University of Texas Press, 1994, and Gerardo Mosquera,
"The New Cuban Art," in Ales Erjavec (ed.), *Postmodernism and the Postsocialist Condition. Politicized Art under Late Socialism*.
Los Angeles: University of California Press, 2003, pp. 208–246.
13. RoseLee Goldberg and Tania Bruguera, "Interview II," in *Tania Bruguera, Op. cit.*, pp. 29–31.
14. See Rachel Weiss (ed.), *Por América. La obra de Juan Francisco Elso*. Mexico City: Universidad Nacional Autónoma
de México and Dirección General de Artes Plásticas, 2000.
15. RoseLee Goldberg and Tania Bruguera, "Interview," in *Tania Bruguera, Op. cit.*, pp. 15–17; Gerardo Mosquera, "Reanimating
Ana Mendieta," *Poliéster*, 4. 11, Winter 1995, pp. 54–55.
16. RoseLee Goldberg, "Regarding Ana," in *Tania Bruguera, Op. cit.*, p. 8.
17. RoseLee Goldberg and Tania Bruguera, "Interview I," Ibid., pp. 11–13.
18. Gerardo Mosquera, "Reanimating Ana Mendieta," *Op. cit.*, pp. 53–54.
19. *Estado de Excepción. Arte de Conducta*. Havana: Galería Habana, 2008.
20. Ibid.
21. Gerardo Mosquera, "Art and Politics: Contradictions, Disjunctives, Possibilities," *Brumaria* 8, Spring 2007, pp. 215–219.
22. RoseLee Goldberg and Tania Bruguera, "Interview II," in *Tania Bruguera, Op. cit.*, p. 19.
23. Claire Bishop, "Antagonism and Relational Aesthetics," October 110, Fall 2004, pp. 51–79.

POLITICAL PEOPLE:
NOTES ON ARTE DE CONDUCTA

...

CARRIE LAMBERT-BEATTY

"I'm a political artist, so I decided that I was going to give my space to people I admire as political people." So said Tania Bruguera from the back of a crowded Chicago lecture hall, as part of the brief speech with which she turned the attention of some two hundred audience members over to Bill Ayers and Bernardine Dohrn on May 1, 2009 and shifted our expectations: from radical art performance to radical political discourse.

It was just months after Barack Obama's acquaintance with 1960s radicals Ayers and Dohrn (now an eminent education professor and the director of a center for juvenile justice, respectively) had been churned into pseudo-scandal by his opponents in the US presidential election. So the couple had more than a little celebrity status among the left-leaning art crowd gathered for Bruguera's presentation, which was held at a commercial art fair but organized as part of the experimental art history conference *Our Literal Speed*.[1] This star power compensated for the disappointment some of us felt at Bruguera's own abdication of the stage. We craned our necks to see the faces of the former leaders of the Weather Underground. We chuckled at their self-deprecating jokes about their age and welcomed their message that artists had a political role to play breaking "out of that controlling frame that limits the horizon of our imaginations." Everyone seemed to nod appreciatively when Ayers contrasted two different memories of Chicago's Grant Park: the first when he was beaten by police during the Days of Rage around the 1968 Democratic Political Convention; the second on election night forty years later, when he stood together with nearly a million other onlookers to hear the country's first black president acknowledge his victory.

Everyone, that is, except a young man, perhaps in his early twenties, sitting a few rows from the back. Not long into the presentation, as Dohrn was taking a look back at the Haymarket uprisings in Chicago in 1886, he interrupted, loudly. "Isn't that all still going on, though?"

"That's what's interesting," replied Dohrn, who had been noting the recurrence in the contemporary immigrants' rights movement of issues that had rallied Americans a century earlier. "But then I don't know where the change is," the young man insisted, referring back to Ayers's two Grant Park scenarios. The couple continued with an inspiring, if somewhat practiced, series of comments about the challenges facing the left early in the Obama administration— "Obama's not going to save us, but with any luck, we can save Obama"—but the heckling continued. Ayers and Dohrn responded like the generous and experienced teachers that they are. But their equanimity and his aggression competed for control of the room. Artist and activist Gregg Bordowitz urged the heckler to "cool out a bit" and remember an adage of the left: "When the enemy's not in the room, we practice on each other." Others, however, jumped in to press Dohrn and Ayers about the kind of change they wanted to see. ("Are you in la-la land?" one questioner asked, exasperated by their argument for prison abolition.) For nearly an hour, the discussion shifted in this way. Congressional budgeting of the war

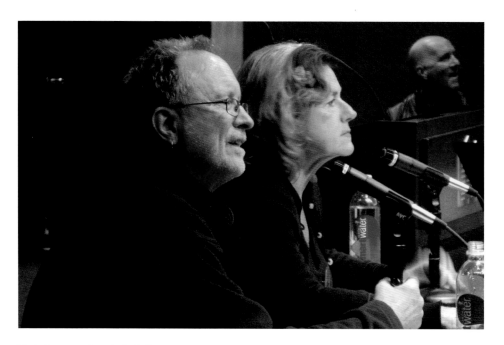

Tania Bruguera, *Generic Capitalism*, 2009
Bill Ayers, Bernadine Dohrn, and respondents
Merchandise Mart Conference Center, Art Chicago
Photograph by Rainer Ganahl

in Iraq. Earnest entreaties about artists' role in society. The prison-industrial complex. And plainly generational squabbling. In one exchange, the young man reminded the couple that they, too, had once been rash and extreme, to which Dohrn responded with a mixture of bemusement and indignation. "We never sounded like you, baby . . . we were way off the deep end, but we never sounded like you."

Everyone in the audience responded differently to what happened in the wake of Bruguera's decision to give over her spot to Ayers and Dohrn, of course. But I suspect many felt, as I did, simultaneously annoyed by and grateful to the unnecessarily argumentative members of the audience. For as distracting and sometimes illogical as they were, they had thoroughly invigorated the conversation. It felt like something real was happening. Ayers and Dohrn seemed to acknowledge as much in the smiles they flashed one another, and an occasional whispered aside—"this is great"—audible over the microphone when the cross-talk in the audience grew particularly impassioned. Dissent had erupted in a conversation about dissent.

Or had it?

Some may have suspected it right away. I didn't, but somehow by the second day of the confer-

ence I knew (strangely, I can't remember exactly how I found out) that four of the most strident interlocutors of Dohrn and Ayers the day before had been planted by Bruguera (she didn't tell them what to say, only to interrupt when they disagreed with the speakers). This simple revelation raised a number of questions. What does it mean that the most interesting leftist political conversation I've been in on in a while was partially staged—its most convention-rupturing moments actually ordained from behind the scenes? Was it necessarily less "real" because it was prodded into being? Was the conversation less democratic, because controlled? Or more so, because dissent is closer to democratic process than is peaceful preaching to the choir? Had we in the audience been lab rats, used in a political experiment? As some audience members complained later, there is a basic affront to dignity in being deceived. As a gesture, moreover, planting combative interlocutors in a political discussion has unpleasant connotations. It recalls the history of infiltration of leftist groups, including Dohrn and Ayers's own, by FBI counterintelligence agents charged with producing discord. And it almost eerily anticipates the wave of falsely spontaneous disruptions of public meetings that American conservatives would use as a tactic later in 2009 to try to block reform of the US healthcare system.

Bruguera calls experiments like this Arte de Conducta. This art of behavior is aimed at "not representing the political but provoking the political," and the Chicago example (titled *Generic Capitalism*) is among the most benign. Other works from the last ten years include bomb-making in an art gallery, a school for critical political performance in a communist state, the supervision of art viewers by security officers and guard dogs, even a very literal game of Russian roulette. In a period in which free meals and beanbag lounges, cafes and rural retreats have been mobilized as art and interpreted in terms of a kind of politics of conviviality, Bruguera is driven to explore forms of oppression, force, and regulation—and often mimetically to inflict versions of them, herself. What is this artist up to?

It would be argumentative, unnecessarily argumentative, to propose that what she is up to is a self-reflexive commentary on art itself.

ARTE DE CONDUCTA

Bruguera came to international attention in the mid-1990s with a decidedly theatrical form of performance. Hers was a politically inflected body art featuring resonant materials like hair, a butchered lamb carcass, soil, and her own naked body. Joseph Beuys's photogenic actions seem a relevant precedent for these works, or the dramatic tableaux of Marina Abramović. She was also influenced by the Cuban-American artist Ana Mendieta (whose oeuvre Bruguera systematically re-enacted in and for Mendieta's native Cuba, early in her own career), and there are faint echoes of Mendieta's evocative imprints of a female form in natural settings, connected to Afro-Cuban religious rites. But in 1973, before the *siluetas*, Mendieta had explored the corporeal trace in a very different way. Leaving a pool of blood on a city sidewalk, she sat back to photograph the reactions—or more disturbingly, non-reactions—of passers-by to the gory puddle. And it is this piece that Bruguera cites as the precedent for Arte de Conducta, the kind of work she has been doing since around 2000.

Bruguera's category of Arte de Conducta overlaps with various versions of performance-in-the-world that artists have explored since at least the 1960s, in attempts to subtract the theatricality from "performance" and overcome its dichotomy of active performer/passive audience, while retaining the duration, unpredictability, and immateriality of art as action. The later "social sculpture" works of Beuys are an example, and Beuys was frequently referenced in Bruguera's Cuban art education. But I find it helpful to look to the American artist Allan Kaprow to understand the evolution of non-theatrical performance. He is best known for coining the word "happening," and for the complex and largely theatrical art events the term designated in the early 1960s. But, frustrated by the ease with which the happenings were recuperated as art-world spectacles (Bruguera, too, found her more theatrical early performances "immediately accepted" and "too easy"[2]), Kaprow spent much of his career thereafter articulating alternatives, using terms like "events," "non-theatrical performance," "unart," "lifelike art," and "re-

search" for a practice that sometimes looked like strange sociology experiments—a man and a woman repeatedly passing through a doorway, trying every combination of holding and not holding the door for one another—and sometimes like meditation—wetting a stone and carrying it until it dried. Indeed, behavioral experimentation and meditative practice might be the two structural poles of the category of non-theatrical performance. On one end, an interest in mindfulness, a commitment to experience and attentiveness for their own sakes (sometimes, as for Kaprow, connected with Zen or other meditative disciplines). And, on the other, practices that take their cue from the scientific study of human behavior.

More directed to public than private experience, based in outward rather than inward attentiveness, and more critical than ameliorative, Bruguera's recent work leans towards the latter pole, as the term Arte de Conducta—"Behavior Art"—suggests. The techniques of Arte de Conducta often evoke social psychology investigations like Stanley Milgram's experiments of 1961. Like Mendieta's *People Looking at Blood* (or in a more benign register, like the audience in Chicago), these experiments involved participants who did not have all the facts about their participation. Believing they were in a study of learning, Milgram's subjects in fact demonstrated how many of us would hurt, perhaps even kill, another person if instructed to by someone in authority. Likewise the infamous 1971 Zimbardo experiments at Stanford, in which students pretending to be guards and prisoners took only days to sink into inter-group hatred and abuse. Debate around these experiments eventually resulted in the strict guidelines and review procedures for behavioral human subject research that are now the norm; protocols designed to cleanse from scientific practice the very insensibility to others' pain that the initial experiments had so dramatically revealed.

No such guidelines regulate art. It's disturbing, but perhaps not surprising that mid-century behavioral science, shaped by a post-World War II imperative to understand human cruelty and aggression, has had currency for artists in the age of Abu Ghraib and Guantanamo. Some of these recurrences have been quite literal (Rod Dickinson's restaging of the Milgram experiment with actors; Artur Zmijewski's Zimbardo redux), but consider Zmijewski's THEM (SIE) (2007), a video documenting a series of sessions in Poland in which the artist brought together activists representing four different political positions (nationalist youth, Catholic conservatives, Jewish activists, and socialists). Given paper and paint, they were invited first to make a large-scale tableau representing their beliefs, then to edit the self-representation of another group. Initially polite, the gestures soon progressed to outright desecration and destruction. By the end, offensive images were being thrown from the window or set aflame.

Like much of Bruguera's art, Zmijewski's workshop can be understood as a precise reversal of the positive visions of sociability in art since the mid-1990s. The paradigmatic example is the Austrian group WochenKlausur, whose artworks often brought together representatives of opposing social groups. These individuals were sequestered in small spaces like a boat or a spe-

cially constructed cabin and provided with a professional mediator and some light refreshment. Privacy and the label of "art"—and perhaps the power of table manners—seemed to suspend established patterns of enmity, producing opportunities for interchange person-to-person that were foreclosed in public discourse.[3] The goal of such socially ameliorative projects—as in the larger category of what Nicholas Bourriaud named "relational" art practices—is to generate sociality itself. But, as critic Claire Bishop has incisively argued, the implied model of interchange in many of these convivial experiments, and in most of the writing about them, is a strangely depleted one: their goal is to produce peaceful accord, but the basis of democracy is dissensus.[4]

DANGEROUS PLAY

Bruguera can be accused of many things, but not of discouraging dissensus.

In *Tatlin's Whisper #5* (2008), a pair of mounted police officers used crowd control techniques to herd art viewers around the huge Turbine Hall at London's Tate Modern. Blocking the exits, grouping and then dispersing the crowd, the officers and their horses treated the audience as if it were convened for a demonstration or rally. Instead of encouraging an ideal of the art audience as a proto-public, Bruguera treated it like a mob. In a place we'd like to consider a zone of freedom, she introduced coercive force. Likewise, in *The Dream of Reason* (2008), an art gallery was patrolled by an increasing number of uniformed security officers with guard dogs. In a second version, museum-goers arriving at an exhibition were patted down and their bags searched before they could enter. ("There is some political art in the show," Bruguera explained to visitors, "we've got to be careful.")

The deployment of security forces in an art space reverberates in many ways, most of them unpleasant. Coming from a society in which censorship is always a possibility, does Bruguera want to remind us what it means for art not to be free? Or does she want us to give up the illusion that we are free of repression in the Western democracies? Is the uniformed surveillance a vision of where we are heading in the paranoid, post-9/11 West? Is it simply an old-fashioned attempt to shock us out of our placidity? Does it critique oppressive, even fascistic tendencies? Or does it exhibit them?

Zmijewsky was able to produce an extraordinary portrait of antagonisms in the particular crucible of post-communist Poland, and a generalizable document of escalation of commitment in political debate—but most likely only at the cost of actually radicalizing, then sending out into the world, the individuals who performed for his camera. Such effects on participants are precisely what regulations and review boards for human subject research are designed to avoid in the sciences. By contrast, they are what Tania Bruguera seeks out; what she considers the work itself. In this she differs somewhat from Zmijewski, whose Polish workshop existed in order to be made into an art video. (In fact, its subject matter amounts to an argument for the social rel-

evance of, of all things, painting.) Bruguera doesn't make videos—those that exist are produced as documentation by the host institutions—or exhibit photographs of her behavior art. (She has actually tried to sell her performances, but only in a way that mocks the whole idea of non-theatrical performance as a product; offering for sale the ownership of whatever performance she does next, for example.) In Zmijewski's case, the art audience contemplates conflict. In Bruguera's, they experience it.

Yet precisely for this reason, it seems to me that it is art and art viewing that this set of projects tries, forcibly, to redefine. The appearance of the crowd-controlling policemen at the Tate implies a crowd that requires control. As Dionorah Pérez-Rementería has pointed out, it presumes the possibility, however unconscious or remote, of violence among normally docile art viewers.[5] Bruguera represents the art audience—represents it to itself—as a potentially dangerous assembly.

This is a remarkable twist on the paradigm in recent art that seems dedicated to reviving interchange and conversation among art viewers, so as to make the art audience less a collection of contemplators than a proto-public sphere. Bruguera, too, wants to change our view of being an art audience, but in the opposite direction. In 2006 she showed how far she would take this tendency when she hosted a Molotov cocktail party: viewers arriving at the opening of her show at a commercial art gallery in Madrid found themselves in a workshop, led by the artist, on producing homemade bombs. (Bruguera describes the dealer, getting into the spirit of the evening, pouring out bottles of wine she had put out for the opening so the lessons could continue.) Here again, art and art viewing are treated as, or rather, made to be dangerous activities. Bruguera happily sent her audience out into the night armed with Molotov cocktails and the knowledge of how to make them: she *actually* made them *potentially* dangerous. Her Arte de Conducta assumes that art viewers are all "political people." And if we are not, she makes it so.

ARTISTIC FREEDOM, INCORPORATED

Bruguera is deeply committed to the avant-garde project of breaking down the boundary between art and life. She speaks about it often. She has expressed her discomfort "with the visual arts and their inevitable distance from life,"[6] and she gave up her more theatrical performances because she wanted "an art in which the artistic nature was not that easy to define and which worked in the realm of life."[7] Unafraid of instrumentalizing art, she is committed to the possibility of rejecting once and for all the modern separation of art and utility, stating that "artwork should not only be useful but should exist in the realm of reality; otherwise, it automatically becomes a representation again, one that exists only in the realm of possibility."[8] She strives for a mode in which art is not "a sample, art is . . . something of real consequence," and wants art "to go from being a proposal to be a working temporary reality."[9]

In fact, Bruguera speaks more and more readily about what art is and should be than most other artists I know. Is it possible that she—whose practice involves activities as unartistic as publish-

ing a newspaper and running a school, who happily accepts that her works are not even always recognized as art —is art's fierce defender? This, at least, is how I understand the many gestures in her recent practice that seem to imagine art and art audiences as forces of disruption.

Bruguera grew up in an art culture that assumed art had a functional social role. In capitalism, art's social function is of course often denied, but more importantly, it is always double: art functions ideologically, reflecting or building culture, and art functions as a market, tied into and supporting the economy. But in revolutionary Cuba, the connection of art to the social is not—or was not supposed to be—double. Cuba's history on artistic control differs significantly from other instances of state communism—for there has never been an imposed state style. But, understood as an integral part of the revolution, for nearly fifty years Cuban art has been held to standards of "ideological rigor." Bruguera is of a generation that came of age just as this system began to falter. Contemporary Cuban visual art has been successful in international markets, and since the collapse of the Soviet Union and the "special economic period" that followed, art has become a valued industry, both for the revenue it brings in directly and for of the cultural tourism it attracts. Moreover, according to sociologist Sujatha Fernandes, as the government has cracked down on political dissidence, it has increasingly tolerated criticality within artistic expression. Fernandes calls this a new mode of "incorporation" in Cuban cultural politics.[10] It sounds familiar: once valued for its meaning, art is now prized for its exchange value. Once controlled as a potentially dangerous signifying force, now it appears tolerated as a source of revenue and a social safety valve. And, as Luis Camnitzer and others have pointed out, the two functions are interrelated: political content in Cuban art is one of its selling points.[11]

These are simplifications, of course, of a complex and quickly changing situation (and one I don't know intimately). But I wonder if in Bruguera's recent work we see an underlying sense of loss. One of the most ambitious of her Behavior Art projects was the Cátedra Arte de Conducta, a long running workshop based at but largely independent from the art institute in Havana. There, over seven years, Bruguera brought in artists, critics, and curators to meet with Cuban students and artists in a series of discussions about political, performative art. Perhaps creating a community of critical artists in Cuba is at least metaphorically comparable to arming a European art audience with homemade bombs. Each appears to be tolerated, but each dares its respective regime to recognize its powes. Bruguera is anything but nostalgic, but perhaps it could be put this way: she grew up in a social experiment, in which art had a function. Now she enacts social experiments to try to give it one, again.

CRAFTING CONFRONTATION

During the conversation in Chicago, Bill Ayers and Bernardine Dohrn, themselves former revolutionaries, repeatedly looked to artists as contributors to social change. The role they seemed to propose was for artists as agents of imagination—Dohrn suggested that they might

be the ones to come up with alternatives to the American prison system; Ayers, that they could counter the limited and limiting narratives created in the news media. Bruguera, a self-proclaimed political artist, would seem just the person to volunteer such imaginative re-framings. But the overall structure of her event—her relinquishment of her space and audience to Dohrn and Ayers—suggested instead that the most an artist could do politically was to sacrifice art to the political.

Of course, once you know that Bruguera had not actually removed herself from that conversation but intervened in it by proxy, the situation gets more complex. She only seemed to make art a window onto politics; only seemed to remove form in favor of content, or the aesthetic in favor of the political. In a sense, this pattern is repeated on a larger scale in her work as a whole, where art seems to disappear into life, but is in fact bolstered and renewed. In Chicago, disagreement *was* form—or better, medium. (*Conducta* translates not only to *behavior*, but also *conduit*.) However open-endedly, Bruguera shaped—imagined—that experience. Does that mean that she fulfills the role of artist as imagination agent? Not if we insist on the benevolence of that role, on the artist as the generator of civility and accord, or even of inventive social solutions and narratives. Bruguera has a different technique: her craft is confrontation.

What does it mean that we seem to need her? That the art Left needs this daughter of the revolution to conjure confrontation itself?

1. More precisely, the venue was a hall at the Merchandise Mart in Chicago. The performance was presented as part of both a lecture series attached to Art Chicago, International Fair of Contemporary and Modern Art, which was being held at the time in the same building, and the experimental art and theory conference Our Literal Speed. In addition to my own memories, my descriptions here draw on conversations with other audience members, an interview with Bruguera at her Chicago studio, August 10, 2009, and an audio recording of the performance. Bruguera did not document the event, but the artist Rainer Gahnal photographed this along with most of the other conference proceedings and was kind enough to share his archive with me.
2. Francesa di Nardo, "Arte de Conducta: an interview with Tania Bruguera," *Janus 22*, January 2007, pp. 79, 81.
3. See, for example, their project in Nuremberg, documented at http://www.wochenklausur.at/projekte/13p_kurz_en.htm.
4. Claire Bishop, "Antagonism and Relational Aesthetics," *October* 110, Fall 2004. Not surprisingly, Bishop has written approvingly of Bruguera's practice. See "Speech Disorder," *Artforum*, Summer 2009.
5. The piece might suggest the argument that disciplinary measures presume and even *create* the very threats they are meant to deter.
6. Francesa di Nardo, "Arte de Conducta: an interview with Tania Bruguera," *Op. cit.*
7. Bruguera interviewed by Gerald Matt in Matt, *Interviews.* Cologne: Walther König, 2006.
8. Ibid.
9. Ibid.
10. Sujatha Fernandes, *Cuba Represent! Cuban Arts, State Power, and the Making of New Revolutionary Cultures.* Durham and London: Duke University Press, 2006.
11. Luis Camnitzer with Rachel Weiss, "Epilogue," Camnitzer, *New Art of Cuba*, Revised Edition. Durham: Duke University Press, 2003, p. 336.

PLATES

· · ·

TRIBUTE TO ANA MENDIETA

• • •

1985–1996

Bruguera re-enacted the performance works of Ana Mendieta
and executed for the first time a number of her concept sketches.
Bruguera's acts of artistic self-identification recovered the spirit of Mendieta
to confront the loss of exile and to unite all Cubans, past and present,
local and foreign, in a shared national imaginary.

Tribute to Ana Mendieta, 1985–1996
Re-enactment of performance work by the artist
Gunpowder, stones, and fabric
Dimensions variable

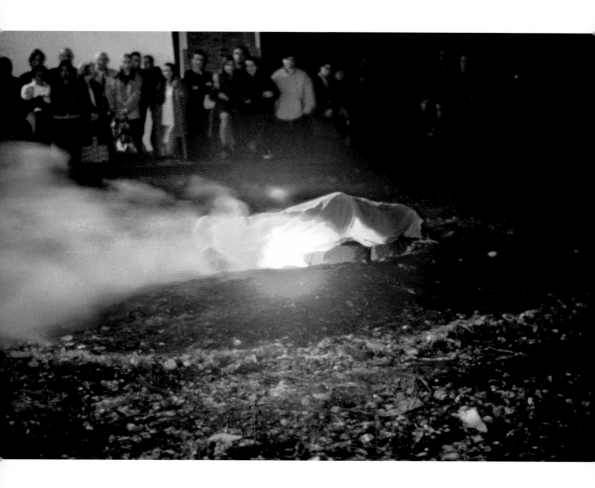

MEMORY OF THE POSTWAR I, II, AND III

• • •

1993, 1994, 2003
In collaboration with local and emigrant artists and critics,
Bruguera created and directed an underground news publication that
featured articles on various subjects including art, literature, and culture.
Adopting the traditional graphic design of editorial, letter, and news sections,
the publication voiced criticisms generally silenced by state censorship of Cuban journalism.
It provided a forum for discussion of unsanctioned topics such
as human rights abuses in Cuba and the consequences of the Cuban Revolution.
The theme of the second issue was exile and migration. The third issue consisted of newspapers
without names, dates, or news that instead featured political slogans used
by the Cuban Revolution and reproduced the original Revolutionary posters.

Memory of the Postwar I, 1993
Collaboration with Cuban artists, black ink, and newsprint
13 2/5 x 8 2/5 inches

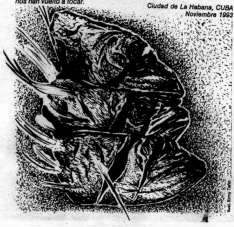

Memory of the Postwar II, 1994
Collaboration with Cuban artists inside and outside Cuba,
black ink, and newsprint
12 1/5 x 8 1/5 inches

Año I, No.2 La Habana, CUBA, Junio de 1994

EL POST-EXILIO Y LA POST-GUERRA
Iván de la Nuez / Juan Pablo Ballester

1. Hay una diferencia radical entre un viaje y un exilio. La experiencia al respecto de los artistas cubanos lo confirma de un modo absoluto. De un viaje el regreso es habitualmente victorioso, con el recuerdo de los buenos tratos, la exaltación de los egos y la sensación maravillosa de haber vivido los 5 minutos de gloria decretados por Andy Warhol. Estos minutos hacían casi tangible el sueño de convertirse en Madonna, Beuys, Harrison Ford o, para variar, Jürgen Habermas. En un exilio, donde los "extraños" - nuevos bárbaros, según la sociología de moda- han llegado para competir por un lugar bajo el sol, los sueños y las posibilidades sufren ligeras variaciones. Las acotaciones del terreno colocan al tope de las aspiraciones en unos paradigmas que se llaman Celia Cruz, Wifredo Lam, Andy García o, para no variar, Guillermo Cabrera Infante. Así, los 5 minutos de gloria de Warhol se nos convierten en 5 minutos de Gloria...Estefan. Y es que los cubanos, como todos los emigrantes, navegan su exilio por los mapas y territorios que se han codificado previamente. Al punto de encontrarse con un mundo de inscripciones que les obliga a vivir en una hiperrealidad delineada por las postales turísticas. El juego que han conseguido estas "marcas tropicales" obedece a unas determinaciones imprecisables. En realidad, nunca sabremos si Cuba vende la imagen que Occidente

prescribe, o éste recoge los dictados que a la isla convienen. En cualquier caso, lo importante no son las jerarquías del origen del juego, sino el juego mismo.

2. Si bien las circunstancias del viaje han sido experimentadas por muchos artistas de la isla, estos desconocen casi todo lo que implica un exilio (que por cierto, suele ser más complejo que una galería, un catálogo o un anuncio en Art in América). Los guettos de "afuera" son complejos, diversificados y se enlazan con diferentes canales de circulación. La, así llamada, vanguardia cubana de los 80 -que fue algo más que "eso: años...y nada más"- ha arribado a distintos países y, aunque siempre ha morado en los ámbitos prefijados, en cada uno se ha implicado de un modo diferente. México, por ejemplo, funcionó como un guetto cultural que insertaba su producción intelectual en espacios e instituciones dedicadas al "problema cubano". Miami continúa como. el espacio por excelencia de la gratificación económica, pasado por el agua, siempre turbia, de la política y por el encuentro con un mundo retro 'tan obsesionado con su "cubanidad" como poco acostumbrado a la estética de la plástica cubana de los 80. Mientras en la Europa de Maastrich, inhóspita con los extraños y embelesada con los nacionalismos,

continúa pág. 10

AÑORANZAS POR CUBA
Emilio Ichikawa Morín

A mis amigos, los que están desde México
"Las piedras de la isla parecen que van a salir volando", dice un verso de la poetisa cubana Dulce María Loynaz, dueña de un premio Cervantes de Literatura, y, a demás, de un silencio tan hablador como el de Sor Juana. En la isla las cosas son leves, y sus definiciones, a veces, parecen bromas; es decir, les falta gravedad: sus ríos son delgados, sus montañas menudas y sus bosques más próximos a los jardines que a las selvas.

Cristo es roca, y Cristo mismo parece que va a salir disparado Quizás por eso el nuestro, macho y marino, se encuentra en Regla, margen insolentemente izquierdo de la bahía desde donde zarpan los barcos.

Las criaturas de la Isla son como sus piedras y también como su Cristo. Parladoras y rumiantes, circulan un aviso que, a fuerza de repetirse, más parece indicar un sentido destinal que un accidente: irse del país. A pesar de las ficciones de algún propagandista, irse es una ficha recurrente en el juego de cualquier cubano y, conste, aunque duela, uno no se acostumbra a irse del lugar donde las cosas le van bien. En buen chuchero: irse es una ficha guardada para cuando el dominó se tranque.

Hasta el idioma quiebra bajo el peso del hábito. Cuando a usted le dicen que fulano se quedó, no le significan que dejó, por ejemplo, una vida bohemia por un nido de hogar o que echó raíces en Escobar, la calle más cálida de la Habana. Nada de eso. Quedarse es dejar, es abandonar, que es también -y eso lo saben quienes se quedaron- la nostalgia por regresar. Nostalgia cada vez menos culpable, pero culpable aún.

El problema radica, para ellos y para nosotros, en que de Cuba uno jamás puede irse, sin darse cuenta de que no hay lugar en el mundo para refugiarse de ella.

Esa escapada desgarradora ocurre en diferentes grados. No estar desde Londres, así se sea un escritor de sensibilidad sin par, es de un extrañamiento más intenso que no estar desde Miami. No estar desde México es, por otra parte, una forma bastante peculiar de ausencia. Tal y como fluyen los acontecimientos, México D.F. llegará a ser, sin dudas la tercera cidad de los cubanos.

Estar y no estar, irse y quedarse, es la tensión que signa a la gente de la isla, de esta isla, y es donde se define en cualquier sitio, dentro o fuera. Sin embargo, ese doble signo es potencia, ora en su extremo, ora en el otro, y es esa potenciación la que llega a hacer distinguibles a algunos cubanos entre sí. Es una distinción de acento, no de cualidad; pero, y esto es lo que quiero advertir, es una distinción que existe.

No estar, irse, es una condición posible. De hecho, hay quienes se fueron y el exilio cubano es una realidad, tenga la textura que tenga. No están o están lejos, porque esto de aquí-ahora no es un ente sino un algo-contingente que permuta todos los días. Cambio acelerado que es capaz de pasmar al

continúa pág. 18

Memory of the Postwar III, 2003
Newspaper without a name, date, or news, political slogans used by the Cuban Revolution,
reproduction of posters of the slogans, red ink, black ink, and newsprint
11 1/5 x 15 9/10 inches

TABLE OF SALVATION

· · ·

1994

Large, wooden ribs are interlaced between adjacent marble slates.
They reflect in the burnished stone to create a spectral double image
and the impression of a structural skeleton in the round, resembling the hull of a ship.
The interstice between each slab is tamped with cotton.
From the series titled *Memory of the Postwar*, this installation is a kind
of cenotaph that memorializes the *balseros* who perished
in makeshift boats on the treacherous flight from Cuba's shores
to the American mainland.

Table of Salvation, 1994
Marble, cotton, and wood
Dimensions variable

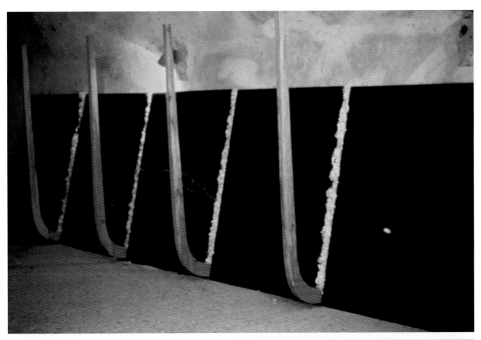

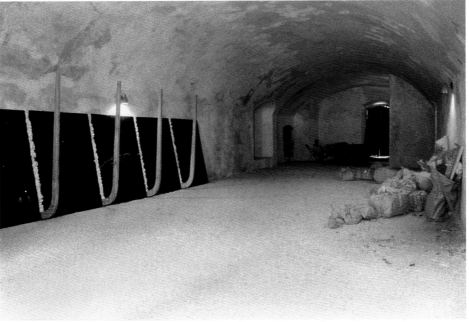

HEAD DOWN

• • •

1996

The political songs and hymns of the "Nueva Trova" movement
resounded in the gallery with revolutionary zeal. The bodies of Cuban artists, critics,
art history students, audience members, gallerists, and curators lay prostrate,
covering a floor staked off by sand bags like war trenches.
In a suit of faux lambskin and a veil of white face paint,
Bruguera tread over the bodies, toting a red samurai-style banner across her back.
She bent down to bind hands and feet and strap eyes and mouths with red cords.
She attached a red band to her body as a memento of each conquest,
and deposited small red flags in the hands of her victims.
This performance was staged first at Espacio Aglutinador,
an alternative gallery in Havana, and lasted about 45 minutes.

Head Down, 1996
Bodies of Cuban artists, art critics, art history students, audience members,
gallerists, and curators, lamb's wool, white paint, flag, red cloth,
and political songs composed during the early years of the Cuban Revolution
Dimensions variable

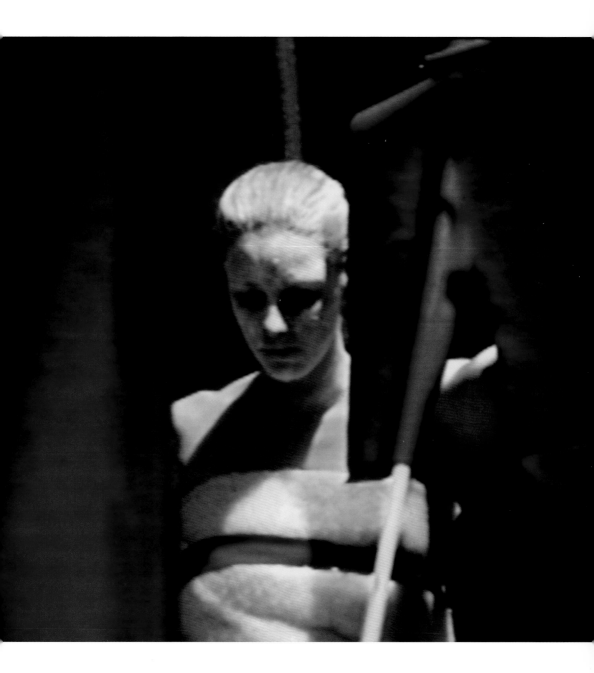

STUDIO STUDY

· · ·

1996

Bruguera balanced precariously above the gallery space on a lofty pedestal.
The artist was naked, and she cupped a hunk of raw meat in her dangling hands.
Clots of cotton amassed around her body and spilled onto the floor below.
Black metal straps bound her head, mouth, stomach, and legs, concealing them like censor
bars and paralyzing the artist in a pendulous limbo for several hours.

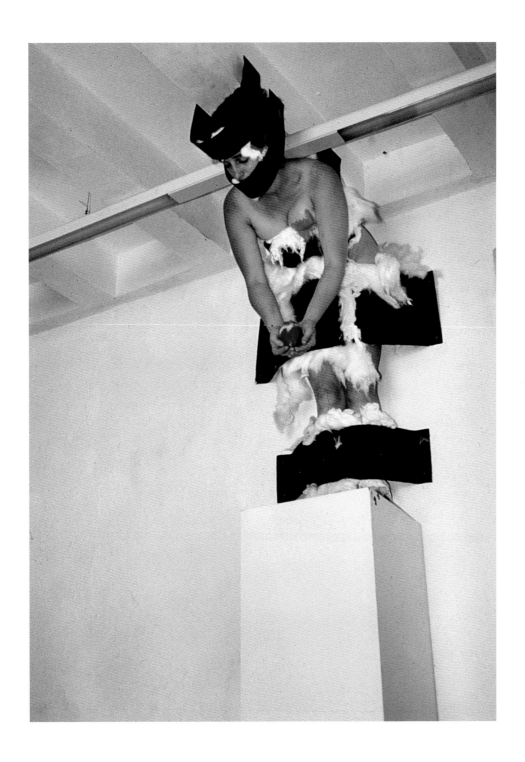

Studio Study, 1996
Pedestal, metal, iron, cotton, and raw meat
Dimensions variable

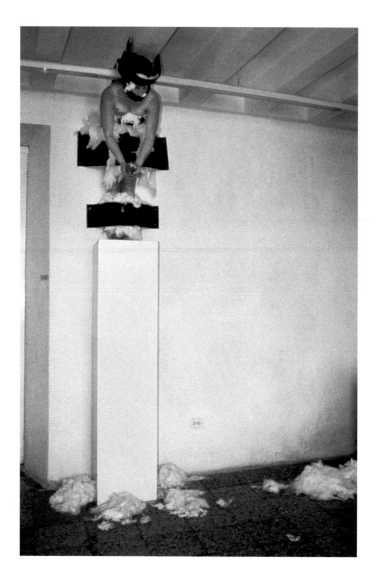

STATISTICS

• • •

1996–1998

A flag was woven from the human hair of anonymous Cubans.
The hair was rolled into strips and sewn onto the recto of a cloth support
that was visible in the round. The design of the ensign recalled the Cuban flag.
This piece was constructed through a five-month collaboration between
Bruguera and Cuban artists and citizens, who contributed their hair
and their labor in manual production.

Statistics, 1996–1998
Human hair, thread, and fabric
11 4/5 x 5 3/5 feet
Private collection, New York

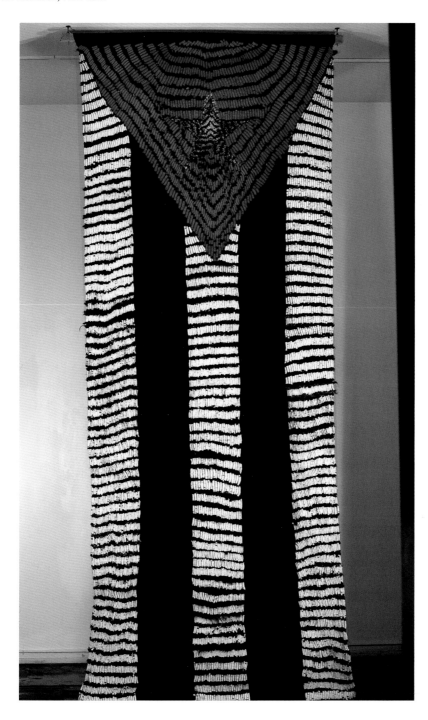

THE BODY OF SILENCE

• • •

1997–1998

Glimpsed through a small entrance, the naked artist huddled
in the darkened corner of a box lined with raw lamb meat.
She marked corrections in an official Cuban history primer for elementary school children.
The artist licked her scribblings in an abortive attempt at self-censorship,
then tore up and consumed the leaves of the re-written,
or denuded, national narrative.

The Body of Silence, 1997–1998
Room, lamb's meat, nails, Cuban history textbook, pen, and saliva
Dimensions variable

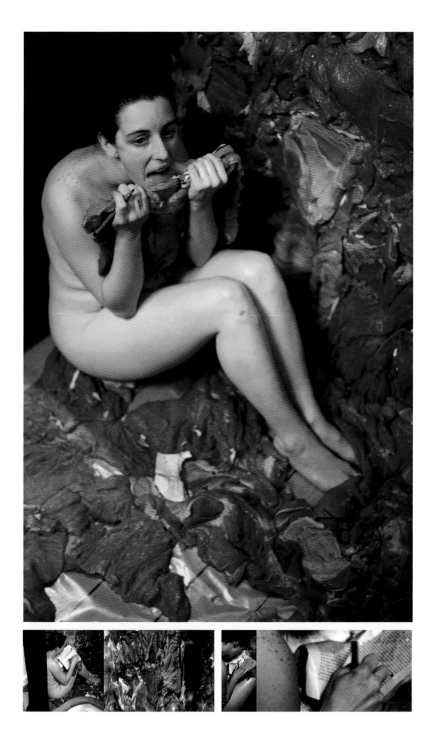

THE BURDEN OF GUILT

• • •

1997–1999

Bruguera recovered a Cuban legend about conflict between
the island's indigenous peoples and the conquering Spaniards.
Unwilling to succumb to the superior force of the invaders, the natives committed
collective suicide as a final act of resistance:
they gorged on dirt, a sacred symbol of permanence, until they died.
In Cuban vernacular, the phrase *comer tierra*, or "to eat dirt,"
came to connote survival through extreme affliction.
Bruguera donned a cuirass-like carcass of lamb and ritualistically
mixed earth and salt water into pellets, which she consumed
for the duration of the piece, or several hours.

The Burden of Guilt, 1997–1999
Re-presentation of an historical event
Decapitated lamb, rope, water, salt, and Cuban soil
Dimensions variable

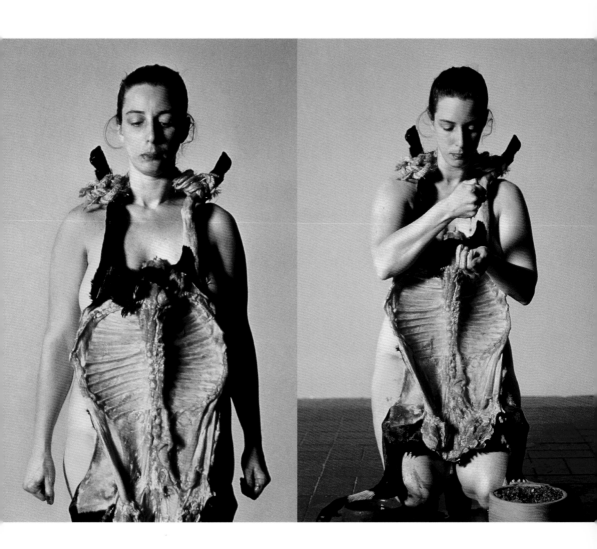

DISPLACEMENT

• • •

1998–1999

Bruguera impersonated the African spiritual icon of Nkisi Nkonde
in full costume. The fetish figure, important in Cuban folk practices,
is believed to grant petitions in exchange for oblations and promises.
Layers of earth cake the Nkisi Nkonde and rusted nails protrude from its frame
to signify the devotions of its supplicants. When people renege on their commitments,
the icon is roused to seek out the wayward worshipper.
The performer stood still for several hours, then awakened
and took to the streets in search of its transgressors.

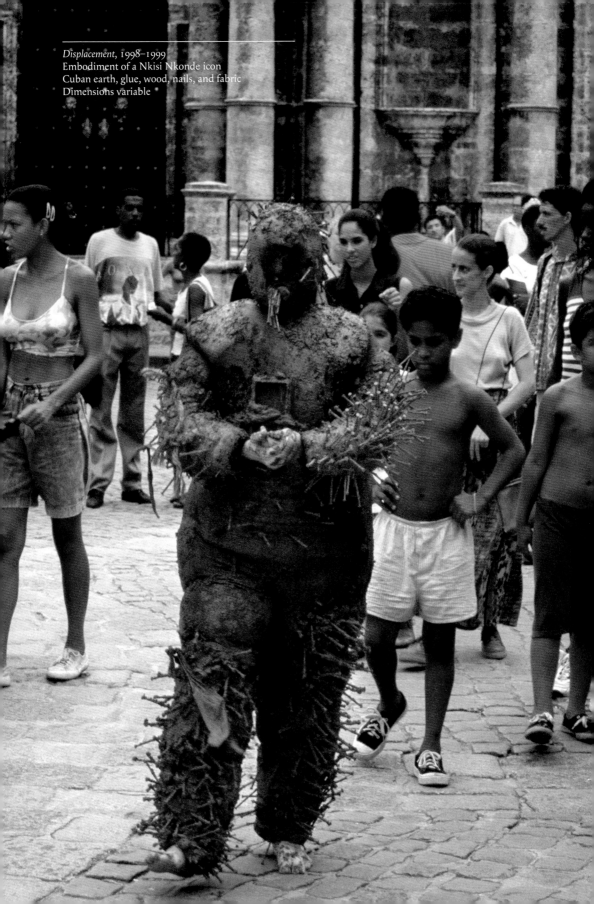

Displacement, 1998–1999
Embodiment of a Nkisi Nkonde icon
Cuban earth, glue, wood, nails, and fabric
Dimensions variable

POETIC JUSTICE

• • •

2002–2003

Bruguera's four-week residency in India inspired this installation.
Small video screens displaying snippets of documentary footage were inserted
within a large wall covered by used, aromatic tea bags. The luminous scenes
combined the dematerialized spectacle of technological modernity with the earthliness
and immediacy of more traditional Indian products. The installation's synergy
of the visual appeal of film with the sensual aroma of tea analogized
the subtle co-optation of reality, news, and information channels
by corporations with the packaging of tea and the consolidation
of empire by British colonial forces.

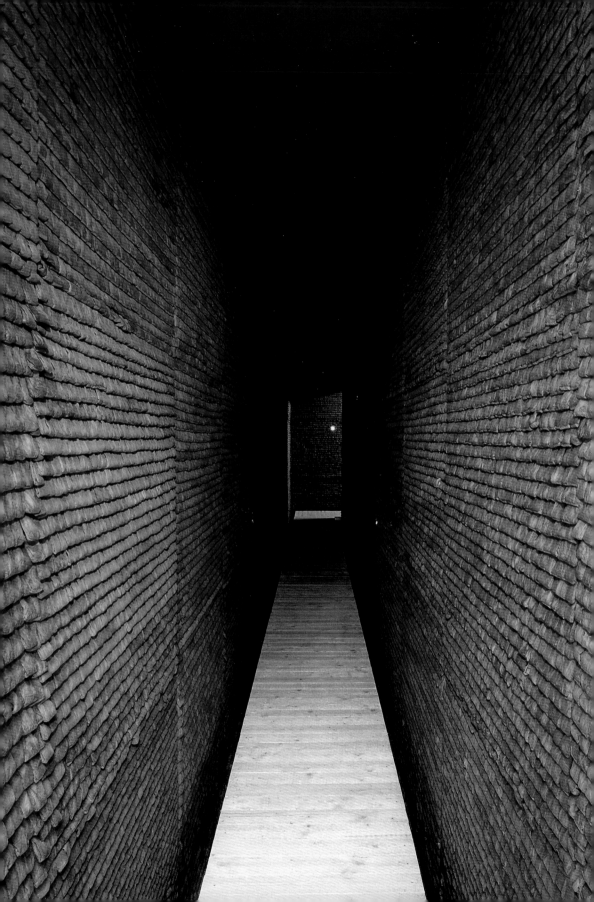

Poetic Justice, 2002–2003
Video installation
Used tea bags, 8 videos from historic newsreels,
8 LCD screens, 8 DVD players and discs
62 3/10 x 6 1/5 x 11 4/5 feet

UNTITLED (HAVANA, 2000)

• • •

2000

The audience entered a cave-like tunnel at La Fortaleza de la Cabaña,
a space formerly used as a penitentiary cell. Underfoot, layers of rotting *bagazo*
or sugarcane husks emitted the noisome stench of fermentation.
The audience traipsed through the dark and the detritus towards
a distant blue light that came into focus as a television screen, displaying silent
looping footage of speeches by Fidel Castro. When they turned around, the audience
noticed naked men ordered regimentally in rows of two, making empty,
repetitive gestures towards their iconic leader. One rubbed his body, while
another wiped his face. One used his fingers to pry open his mouth, and the last bowed.
Collective progression through the space and time of the installation
made visible to the audience the senseless rituals of the subjects
they had failed to notice along the way.

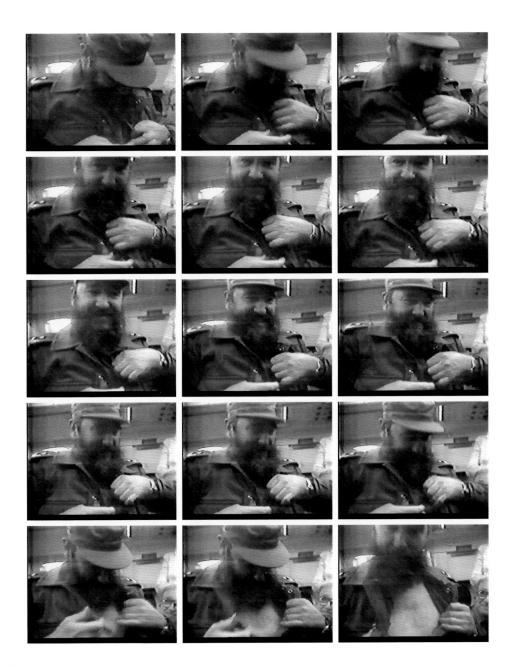

Untitled (Havana, 2000), 2000
Video performance installation
Cubans, milled sugar cane, black and white monitor, and DVD player and disc
Dimensions variable
La Fortaleza de la Cabaña, 7th Havana Biennial

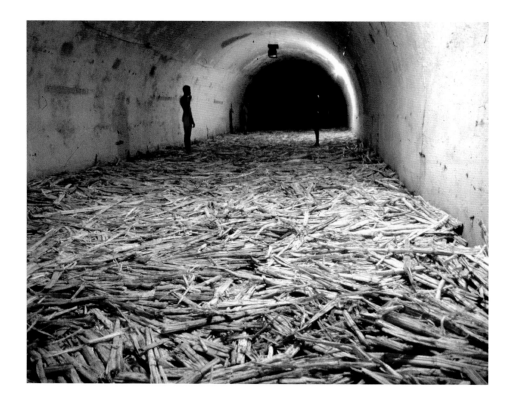

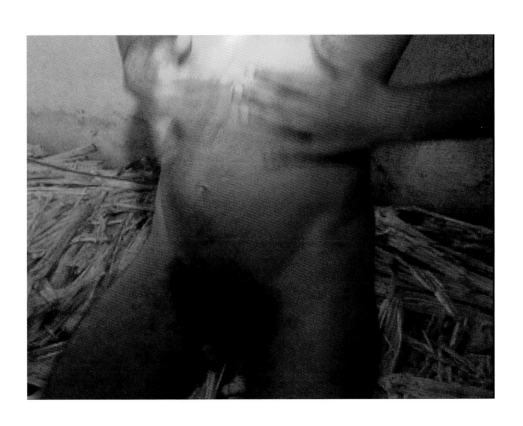

UNTITLED (KASSEL, 2002)

• • •

2002

The performance was held in the city of Kassel, Germany,
the site of a large ammunition factory during World War II.
Strung on a trestle above the entrance to the installation, blazing 750 watt lights
assaulted the vision of the audience. When the lamps were switched off
for a few seconds, the spectators regained their vision and realized
that a continuous metallic clicking noise was the sound of a person loading
and reloading a gun. A projection could be seen displaying the names
of sites where political massacres have occurred since the end of World War II.
The darkness of the space allowed the audience to explore the past as well
as the conditions of their own vulnerability.

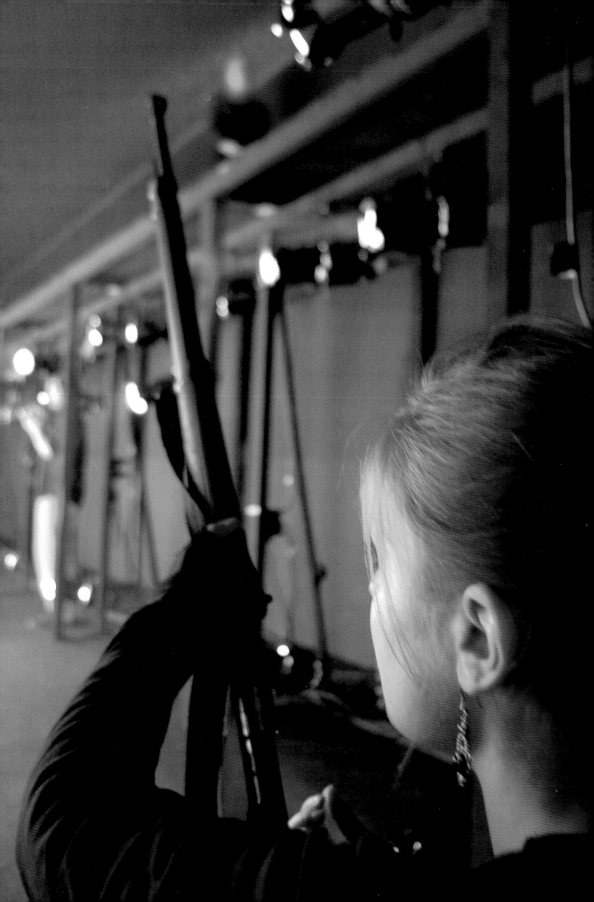

Untitled (Kassel, 2002), 2002
Video performance installation
Germans, guns, black outfits, wood scaffolding,
40 750 watt lights, projector, and DVD player and disc
Dimensions variable
Documenta 11, Kassel, Germany
MMK Museum für Moderne Kunst Frankfurt/Main
Purchased with the generous support of the 3 x 8 Fond,
a city of Frankfurt/Main initiative by 12 Frankfurt-based companies

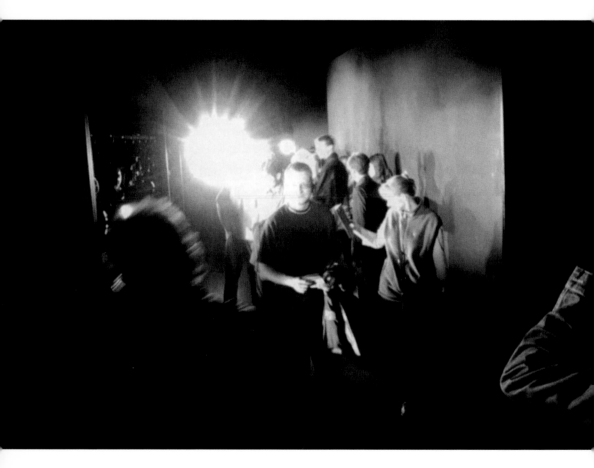

UNTITLED (MOSCOW, 2007)
OR TRUST WORKSHOP
· · ·

2007

Bruguera invited Russian citizens to share with the workshop conductor,
a former KGB agent, their lingering distrust of Soviet officials.
They told stories of personal misfortune or political persecution.
The agent used specialized skills acquired in Cold War training
to redress the harmful psychological repercussions of the era
and to mend the generational and ideological gaps
that separate the Russian people.

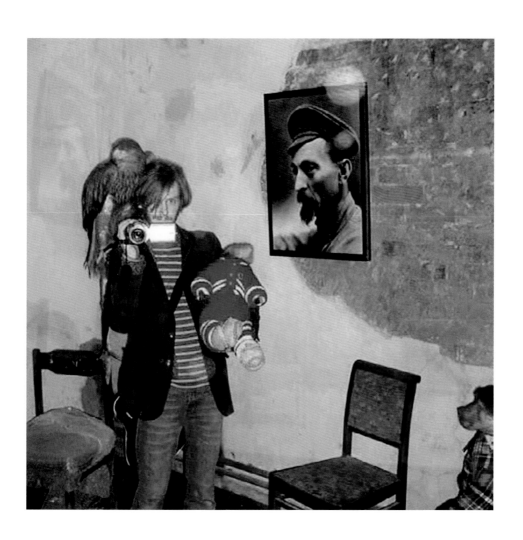

Untitled (Moscow, 2007) or Trust Workshop, 2007
Former KGB agent, street photographer, eagles, monkeys,
photographic paper, printer, ink, and photograph of Felix Dzerzhinsky
Dimensions variable
2nd Moscow Biennale of Contemporary Art

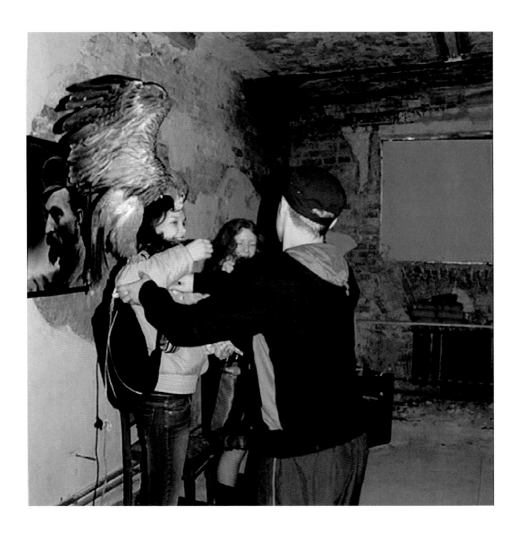

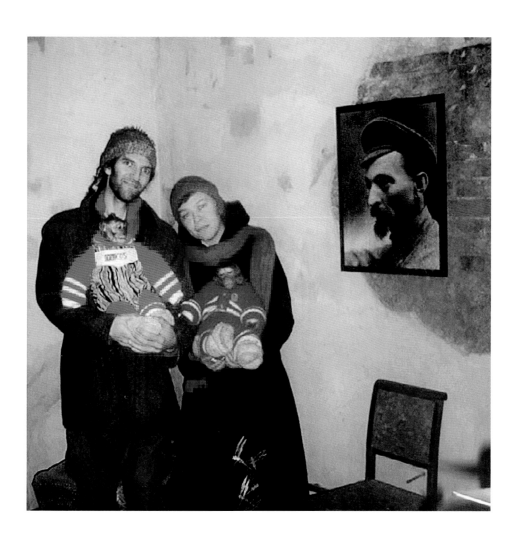

UNTITLED (BOGOTÁ, 2009)

· · ·

2009
This performance took place at the Facultad de Bellas Artes
at the Universidad Nacional de Colombia in Bogotá. Three performers representing
a paramilitary officer, a guerilla, and a refugee displaced by ongoing political conflict,
stood before the same microphone and addressed the crowd simultaneously.
During these jumbled orations, another figure waded through the audience bearing
a tray lined with cocaine for their consumption. Several people tasted the drug,
while others railed against the illegal activity.
Bruguera took the stage and thanked the Colombian audience before promptly exiting.
Anonymous witnesses summoned the police to the scene.

Untitled (Bogotá, 2009), 2009
3 performers (paramilitary officer, guerilla,
and refugee), microphone, and cocaine
Facultad de Bellas Artes, Universidad Nacional de Columbia,
Bogotá

CÁTEDRA ARTE DE CONDUCTA

• • •

2003–2009

Creation of a study center in Havana in collaboration
with Cuban and international artists and institutions.
In a country with Socialist aspirations and doctrines, in which art is seen
as a propagandist tool as well as an agent of change (mostly through education),
Arte de Conducta confronts the contradictions and transitions
of a society undergoing ideological and economic redefinition.
Arte de Conducta engages in a fight for the image, valued equally by the project of the revolution.
It is created and tailored for a young generation of Cuban artists who face the question
of how to combine old values with new ones, as alien as they are confusingly desired.
In its pedagogical presentation, Arte de Conducta combines and nourishes different aspects
of creativity, and its program includes varied instructors: a mathematician who explains
the axiom as a creative tool; a lawyer who discusses intellectual property law;
an architect who talks about concepts of public space; an anthropologist who lectures
about the cultural value of myths; a journalist who gives assignments on how to construct "truth";
and a sociologist who explores her discipline's methods for thinking about
and analyzing societies. Also included are artists and critics whose research and production
focus on the socio-political, the performative, and the behavioral.
The goal of Arte de Conducta is to explore the ways in which art can be active in society,
and in which behavior can become a material of an art that challenges social limitations.
Arte de Conducta does not attempt to give voice to society's others, but to become other.

Yali Romagoza, *Normal is Good*, 2009
Clothing collection
Photograph by Ezequiel O. Suárez
©Yali Romagoza

Cátedra Arte de Conducta, 2003–2009
Creation of a study center in Havana

Yaima Carrazana Ciudad, *Todo en orden (All in Order)*, 2004
Public intervention, ink on paper
Photograph by Mailyn Machado

Núria Güell, *Ayuda humanitaria (Humanitarian Aid)*, 2008-2011
Public service, marriage
Photograph by Mailyn Machado

Hamlet Lavastida, *Acción comentada (Interpreted Action)*, 2004
Video
Photograph by Mailyn Machado

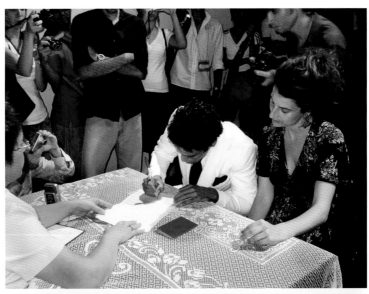

AUTOBIOGRAPHY
(VERSION INSIDE CUBA)

• • •

2003

Members of the audience voluntarily recited the political slogans
of the revolutionary generation before a microphone.
The positioning of the microphone reoriented their bodies so that they stood
with their backs towards the assembled, in address to a white wall.
The loudspeakers repeated their slogans endlessly, until the political imperatives
of the speaker had been lost on the audience as a din of pure sound.

Autobiography (Version inside Cuba), 2003
Painted white space, 2 Soviet speakers from the 1970s, security guard, egg carton,
wood stage, 16 subwoofers, disconnected microphone, 3 unfinished sheet rock walls, and electric bulb
65 3/5 x 49 1/5 x 16 2/5 feet
Courtesy Daros-Latinamerica Collection, Zürich

VIGILANTE:
THE DREAM OF REASON
• • •

2004

Each performance in this series took place aboard an airplane
for the duration of its flight to or from the United States. The passenger adjacent to the artist
recorded her actions and interactions with fellow travelers on video.
On one flight, Bruguera placed an ice cube in her mouth and thrust both hands in after it,
then recited, incomprehensibly, the poem "Ithaka" (1911) by Constantine Cavafy.
On another occasion, she paraded through the aisles wearing a dental device resembling
a gas mask and a T-shirt with the bold text "Dissent Without Fear."
These performances explored the profusion of fear and the limited sphere
of permissibility aboard an airplane in the post-9/11 era, as well as the roles of vigilance
and eyewitnesses in the transmission of experience.
The title of the series derives from Francisco de Goya's engraving
The Dream of Reason Produces Monsters (1799), which portrays a dreamy romantic
tormented by the nightmarish visions of his own imagination.

Vigilante: The Dream of Reason, 2004
Airplane exiting or entering the United States, artist, and passengers
Dimensions variable

PROCESS GIORDANO BRUNO:
FOR A PATRON SAINT OF POLITICAL MEMORY
• • •

2006

This ongoing project consists of Bruguera's preparation of a plan
and petition to the Vatican for the canonization of Giordano Bruno
as Patron Saint of Political Memory. Bruno was a sixteenth-century mathematician,
mnemonic theorist, and proponent of heliocentrism, who was burned at the stake
for his heterodox theories by the Roman Inquisition.
Bruguera's project examines his legacy as a martyr for free thought and explorer
of human memory, and appropriates them in a tautological relationship
between contemporary art and historical acts of political dissidence.
It includes an intensive research component, and provides for the establishment
of a series of ritual events to proceed over the course of a year.

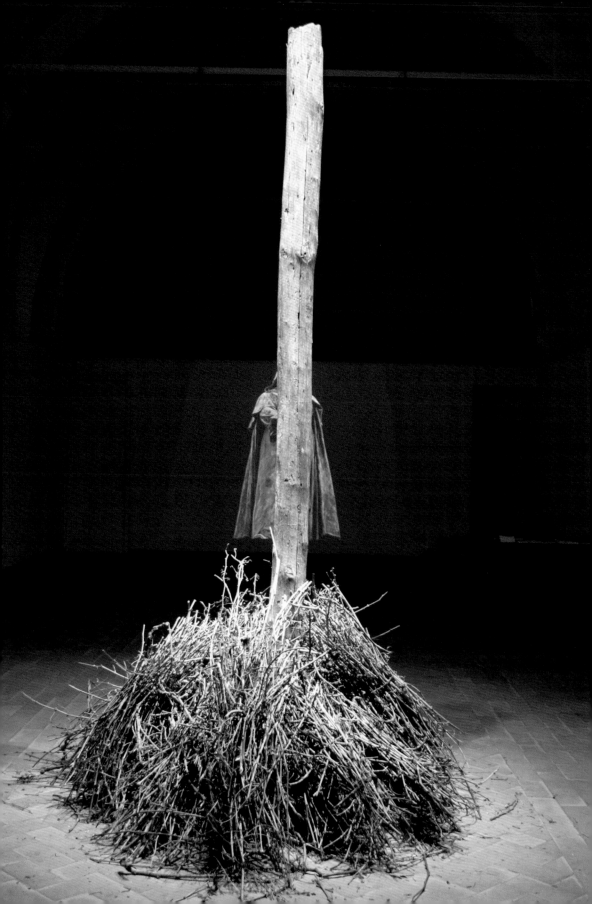

Process Giordano Bruno: For a Patron Saint of Political Memory, 2006
Plan, petition, exhibition, research portfolio, and website
Multiple venues

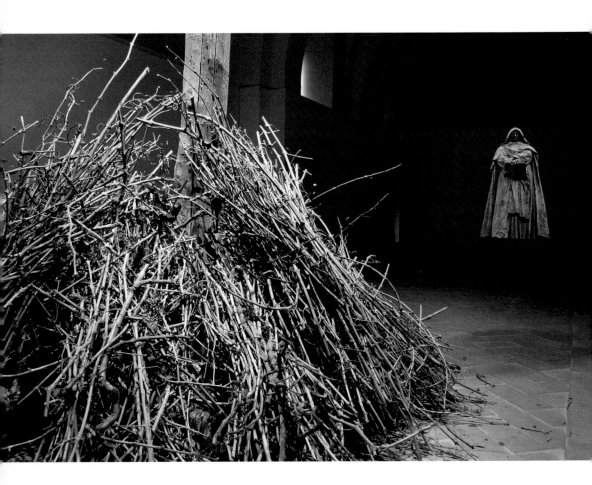

L'ACCORD DE MARSEILLE

• • •

2006

Bruguera signed a notarized agreement with artist J. Castro
stating that when one of them dies, the other will present a performance
using his or her dead body. The work may take several forms
including a collaboration, a legal agreement, a public question and answer session,
an object to be displayed in a museum, and the performance itself.
Like much of Bruguera's work, the accord blurs the boundaries
between art and life.

...artiste survivant privilégiera les institutions qui s'intéressent à l'art et au droit.

16- L'artiste survivant et ses ayant droits disposeront d'un droit de veto s'ils considèrent que les conditions d'exposition de « l'Accord de Marseille »ne respectent pas l'intégrité et les intentions originales de l'oeuvre.

17- En cas de mort avec disparition physique complète du corps de l'artiste défunt, l'artiste survivant pourra décider de faire une œuvre intitulée « L'accord de Marseille » ou de mettre fin à l'accord.

A Marseille le 8 Decembre 2006.

Tania Bruguera

Jorge Luis (Jota) Castro

Enregistré à : S.I.E DE MARSEILLE 5/6EME POLE ENREGISTREMENT
Le 08/12/2006 Bordereau n°2006/2 442 Case n°17 Ext 10597
Enregistrement : 125 € Pénalités :
Total liquidé : cent vingt-cinq euros
Montant reçu : cent vingt-cinq euros
La Contrôleuse

Mme Sophie BARET
Contrôleur
04 91 17 98 17

L'accord de Marseille, 2006
Collaboration with J. Castro
Lawyer, notary public, payment for services, and legal agreement

TATLIN'S WHISPER #5

· · ·

2008

Mounted on horseback, two uniformed policemen appeared
on the crowded bridge of Turbine Hall at the Tate Modern in London.
They marshaled the audience through the gallery space using
a series of crowd-control techniques. They rounded up spectators
into a central pool, divided them, blocked off the exits, and so on.
The audience complied fully.

Tatlin's Whisper #5, 2008
Mounted police, crowd control techniques, and audience
Tate Modern, London
Collection of the Tate, London

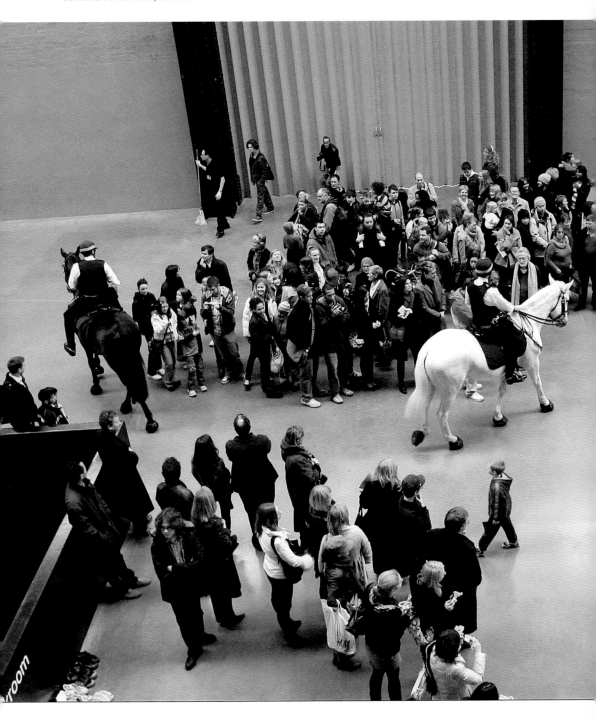

TATLIN'S WHISPER #6
(HAVANA VERSION)
• • •

2009
A microphone stood on a raised podium in the central courtyard
of the Centro Wifredo Lam. The audience was issued two hundred disposable cameras
to document the performance and was told that they could each speak freely for one minute.
A long pause ensued. The first woman to ascend the stage wept
as she grasped the microphone. A man and woman in military fatigues placed
a white dove on her shoulder and on the shoulders of the speakers that followed,
recalling the moment a dove alighted on Fidel Castro during a famous speech of 1959.
Nearly forty people spoke in total; their cries for *libertad* echoed for an hour,
after which time Bruguera ended the performance and thanked the Cubans
for attending. In subsequent days, the biennial's organizing committee
published a renunciation of the participants' comments,
claiming they had co-opted the event to discredit the Cuban Revolution.

Tatlin's Whisper #6 (Havana Version), 2009
Stage, podium, microphone, loudspeakers, curtain,
2 people in military fatigues, dove, audience, and 200 disposable cameras
Wifredo Lam Center, Havana
Berezdivin Collection, San Juan, Puerto Rico

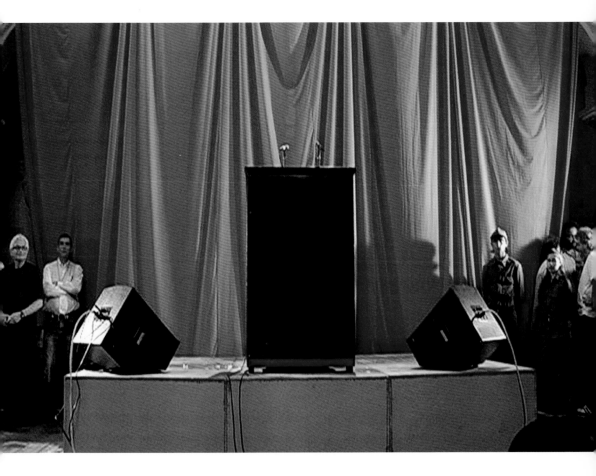

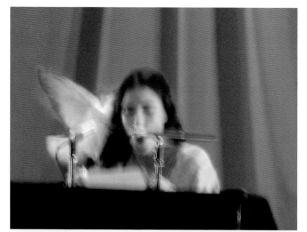

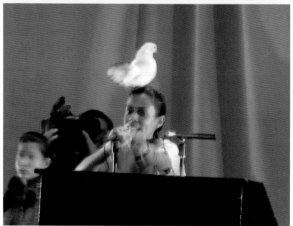

CONSUMMATED REVOLUTION (1968–1989)

• • •

2008

This three-day performance took place in front of the imposing edifice
of the Palace of Culture and Science in Warsaw, a building originally gifted by
and dedicated to Joseph Stalin, now a vestige of the Soviet Union's former political hegemony.
Nine blind performers in military fatigues patrolled the site, tracing the perimeter at a lugubrious pace.
Men and women both, these guards made sexual advances to passers-by,
proposing to spend the night or perform phone sex.
Their advances were thwarted, and their longings, unfulfilled. This performance was part
of a three-day seminar conducted at the Museum of Modern Art, Warsaw,
dedicated to the analysis of the relationship of art in Central and Eastern Europe to its tumultuous
post-war history, from the Polish political crisis of 1968 to the revolutions of 1989.

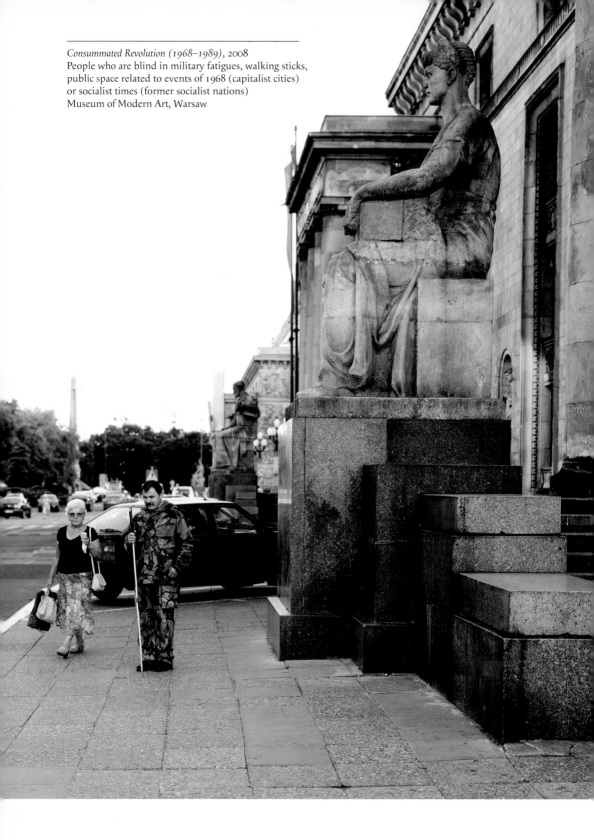

Consummated Revolution (1968–1989), 2008
People who are blind in military fatigues, walking sticks,
public space related to events of 1968 (capitalist cities)
or socialist times (former socialist nations)
Museum of Modern Art, Warsaw

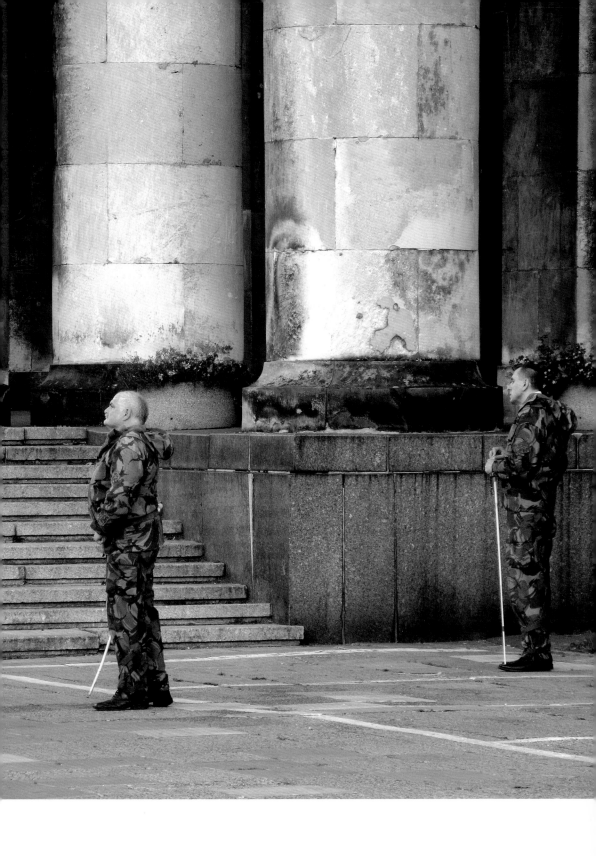

GENERIC CAPITALISM

· · ·

2009

Bruguera abdicated the stage of a crowded Chicago lecture hall to 1960's leftist radicals
Bill Ayers and Bernardine Dohrn: "I'm a political artist," she announced,
"so I decided that I was going to give my space to people I admire as political people."
Ayers and Dohrn mused about the role of art in politics and reminisced about their days
with the Weather Underground. As Dohrn began discussing the Chicago Haymarket uprisings of 1886,
a young man interrupted and questioned, "Isn't that all still going on, though?"
The speakers maintained their composure, while the heckling intensified.
Contentious voices multiplied and the room erupted in vehement debate.
Bruguera had planted the most ardent agitators with instructions to interrupt the proceedings
when they disagreed with the speakers. Given no warning,
the audience assumed that the dialogue and dissent were extemporaneous.

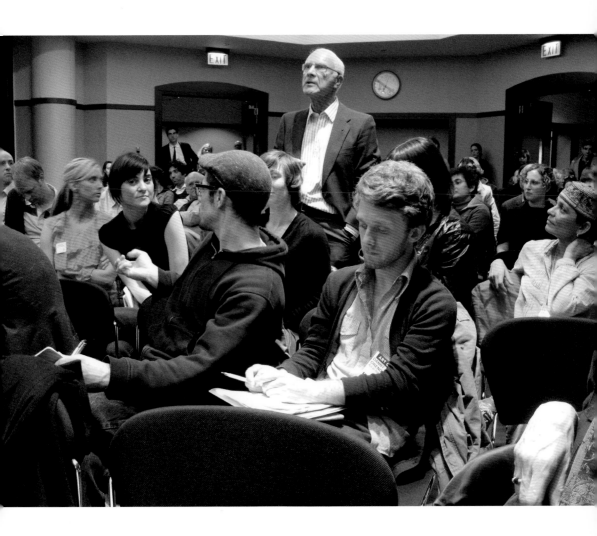

Generic Capitalism, 2009
Bill Ayers, Bernadine Dohrn, and respondents
Merchandise Mart Conference Center, Art Chicago

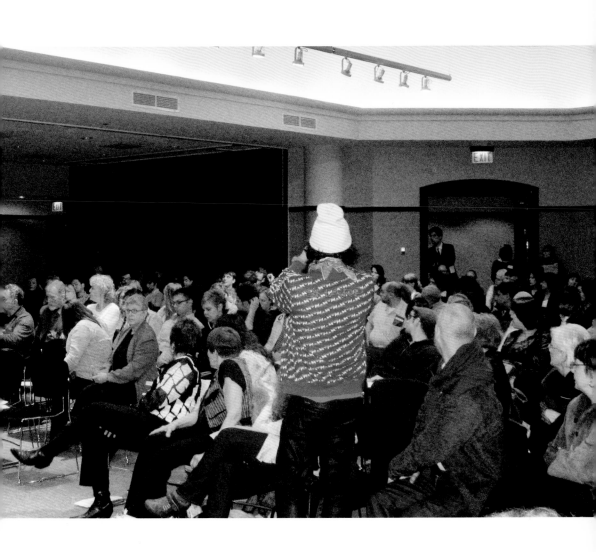

SELF-SABOTAGE

• • •

2009

Bruguera lectured before several rows of spectators
at the Pabellón de la Urgencia (Fear Pavillion) of the 53rd Venice Biennale.
She read an academic text about art's role in political discourse,
then paused and picked up a revolver from the desk in front of her.
Bruguera spun the drum, upraised the gun to her temple, closed her eyes, and shot.
Murmurs rippled through the audience about the authenticity of this game of Russian roulette.
Bruguera continued her lecture, and stopped again to test fate, and the second canister.
Someone began to cry. Others protested weakly. Bruguera continued to speak:
"Political art should stop using references and start creating them."
She rebuffed the audience's entreaties, raised the revolver, and pulled the trigger
for the third time. She fired the last bullet into the ceiling, rupturing a wooden strut.

Self-Sabotage, 2009
Public conference
Table, chairs, microphone, sound system, gun, and bullets
53rd Venice Biennale

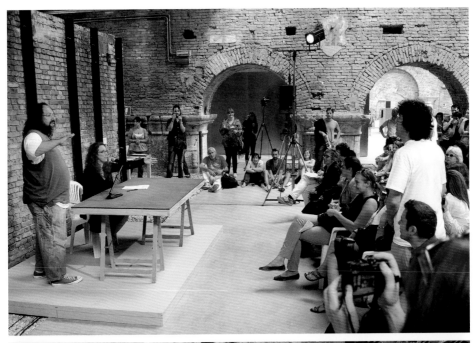

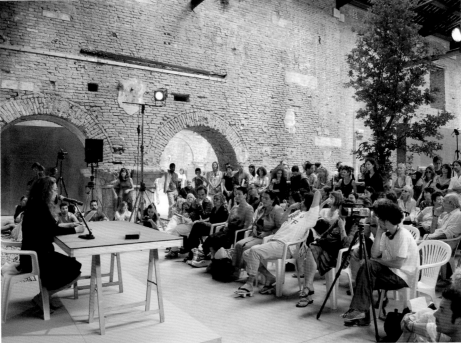

SURVEY

• • •

2010

A docent is a person who leads guided tours in a museum.
Bruguera enlisted several people who are blind to serve as docents
for her survey exhibition at the Neuberger Museum of Art.
They escorted visitors through the exhibition and discussed the meaning of Bruguera's work.
These docents promoted an alternate understanding of "visual art"
that goes beyond the optical, to a more complex,
multisensory, and conceptual understanding of the material.

Survey, 2010
Docents who are blind
Neuberger Museum of Art, Purchase, New York

APPENDIX

. . .

BIOGRAPHY BY NICOLE BASS

1968–1979

Tania Bruguera was born in Havana, Cuba in 1968. The island was still reeling from the deaths of Che Guevara and fellow revolutionary Tania the Guerrilla, Bruguera's namesake. Bruguera's father was a diplomat in the revolutionary government, and his career took the family to Paris from 1973-1974; to Lebanon from 1974-1977 in the early years of the Lebanese Civil War; and to Panama from 1977-1979. In 1979, Bruguera's parents divorced over political differences. She returned to Cuba with her mother and sister, where she encountered a socialist reality that belied the revolution's ideological vision.

Miguel Brugueras, the artist's father (center, wearing glasses) with Ernesto "Che" Guevara during a visit to the offices of *Verde Olivo* magazine, Havana, circa 1962.

1980–1983

At the age of twelve, Bruguera began to study art at the Escuela Elemental de Artes Plásticas in Havana. Sweeping curricular changes incorporated student input and introduced Bruguera to interdisciplinary and experimental art practices. Under the instruction of Juan Francisco Elso Padilla and Heber Rojas, classes abandoned the traditional studio space and took to nature and the streets.

1984–1992

The contemporaneous emergence of the group known as *los '80s* radicalized Cuban art praxis. Influenced by North American conceptual art and the advent of perestroika, the eighties generation viewed their art as a weapon and agent of freedom. Their recuperation of themes and subjects long proscribed by government censorship was the art community's first collective effort to challenge official positions on the country's cultural life. Bruguera was a student of these changes: the proliferation of happenings, the popularization of semiotics, and Cuban art's new activist agenda. This period of cultural and critical ferment formed the basis of Bruguera's art of social effectiveness.

In 1986, Bruguera performed the first in a series of reenactments of the work of Ana Mendieta at Fototeca de Cuba in Havana, beginning a ten-year project to recover Mendieta's legacy from official policies aimed at erasing the cultural contributions

of Cuban expatriates. Controversy ballooned when the Estate of Ana Mendieta initially opposed *Tribute to Ana Mendieta* as an intervention into its own recuperative program. In 1996, Bruguera destroyed all vestiges of the series after the final performance at the Institute of International Visual Art in London, quieting conflict and emphasizing the ephemerality and immateriality of her conceptual work.

1993–1999

Following her graduation from the Instituto Superior de Arte in Havana, Bruguera joined the faculty as an assistant professor. At the same time, under the direction of the Tomás Sánchez Foundation, she began teaching at the Escuela de Conducta "Eduardo Marante," a school for the social rehabilitation of low-risk juvenile offenders. Bruguera utilized art to reform and reeducate students. Her work suspended her between the autonomous world of high art and the reality of social instability. Bruguera would reconcile the two in her formulation of Arte de Conducta *(Behavior Art)*, a new art form for the critical investigation of social behavior.

In 1993, Bruguera created *Memory of the Postwar* to draw attention to the void in the Cuban artistic community left by the mass migration of *los '80s* under extreme political and creative pressure. The rapid censorship of *Memory of the Postwar I* did not deter her from publishing *Memory of the Postwar II* the following year. The second publication

achieved wider underground circulation but elicited greater official reproach. Bruguera was admonished and questioned by the director of Cuba's National Council for Visual Arts and forbidden to continue this work.

Bruguera achieved critical success at the 5th Havana Biennial in 1994, marking the beginnings of her international career. That same year she participated in the Whitechapel Art Gallery's watershed exhibition *New Art from Cuba*, which defined a new generation of major Cuban artists. Soon after, Bruguera left her teaching posts and concentrated fully on her artistic development.

In 1996, the artist represented Cuba at the 23rd São Paulo Biennial, the only time she has headlined a national pavilion She completed a residency in 1997 at The Western Front, Vancouver, where she began to incorporate video and documentation into her work. In 1998, Bruguera was awarded a Guggenheim Fellowship. After completing a residency program organized by Art in General in Chicago, Bruguera moved there part-time to pursue an MFA in performance at The School of the Art Institute of Chicago.

2000–2010

Bruguera was energized by the gritty political tenor of Chicago's art scene and its history of political action groups and events, like the Weather Underground

Organization, the Black Panthers, and the demonstrations at the 1968 Democratic convention. Unsatisfied with the theatricality of performance art, the limitations of body art, and the feminist critical industry that sprang up around them, Bruguera began to remove her body from her work and to explore social politics through audience conduct. *Untitled (Havana, 2000)* was Bruguera's first major work of Arte de Conducta and her first investigation into the political imaginary of places.

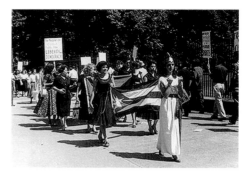

Argelia Fernández, the artist's mother, leading a demonstration against the Batista regime in front of the White House, Washington, D.C., August, 1957.

In 2001, she was invited by Harald Szeemann to participate in the Venice Biennale. The following year, Bruguera exhibited *Untitled (Kassel, 2002)* at Documenta 11, her first work as an international artist without an explicit Cuban context. With the view that education is essential to effecting lasting cultural and political change, Bruguera founded and directed the Cátedra Arte de Conducta at the Instituto Superior de Arte in 2003, the only school exclusively dedicated to the study of political art in Latin America. The institution closed its doors in April 2009.

More recently, Bruguera has continued teaching, primarily at the University of Chicago and IUAV in Venice, and exhibiting at international venues. In 2007, she began her most ambitious project to date, the creation of a political party for immigrants to be based in Paris. The following year, Bruguera exhibited *Tatlin's*

Whisper #5 at Tate Modern, later acquired by the museum, which explored the transformation of an art audience into a functioning citizenry. In 2009, she created *Self-Sabotage* for the 53rd Venice Biennale and *Tatlin's Whisper #6 (Havana Version)* for the 10th Havana Biennial, and she roused extraordinary controversy with *Untitled (Bogotá, 2009)* at the Hemispheric Institute of Performance and Politics in Bogotá. These works explored the conditions that politicize art and its audiences, and they argued for art's centrality to everyday life.

In 2010, Bruguera became the first recipient of the Roy R. Neuberger Exhibition Prize awarded to an innovative, international artist for an early career survey presented at the Neuberger Museum of Art, Purchase, New York.

Born in Havana, Cuba, 1968
Lives and works in Chicago, Paris, and Havana.

. . .

EDUCATION

1980-1983
Escuela Elemental de Artes Plásticas "20 de Octubre,"
Havana, Cuba

1983-1987
Academia de Artes Plásticas San Alejandro, Havana, Cuba

1987-1992
BA, Instituto Superior de Arte, Havana, Cuba

1999-2001
MFA, The School of the Art Institute, Chicago

. . .

PROFESSIONAL EXPERIENCE

September 1992 – June 1994
Coordinating Director, Project for Children with Behavioral
Disabilities, Tomás Sánchez Foundation, Havana, Cuba

September 1992 – June 1996
Assistant Professor, Instituto Superior de Arte,
Havana, Cuba

January 2002 – May 2002
Visiting Artist/Visiting Faculty, San Francisco Art Institute

June 2002 – August 2002
Resident Faculty, Skowhegan Residency Program, New York

September 2004 – June 2006
Adjunct Professor, The School of the Art Institute
of Chicago

February 2008
Visiting Faculty, Cátedra Juan Gris, Universidad
Complutense, Madrid, Spain

January 2006; 2007; 2009 – March 2006; 2007; 2009
Visiting Faculty, Universitá IUAV di Venezia, Venice, Italy

January 2009 – March 2009
Visiting Faculty, Ecole des Beaux-Arts, Paris, France

January 2003 – April 2009
Founder/Director, Cátedra de Arte de Conducta,
Instituto Superior de Arte, Havana, Cuba

September 2006 – Present
Assistant Professor, Department of Visual Arts,
University of Chicago

. . .

SOLO EXHIBITIONS

1986
Marilyn is Alive, Galería Leopoldo Romañach,
Academia de Artes Plásticas San Alejandro, Havana, Cuba

1992
Ana Mendieta, Sala Polivalente, Centro de Desarrollo
de las Artes Visuales, Havana, Cuba

1993
Memoria de la Postguerra, Galería Plaza Vieja,
Fondo Cubano de Bienes Culturales, Havana, Cuba

1995
Lo que me Corresponde, Artist's Home, Havana, Cuba
Soñando, with Fernando Rodríguez, Gasworks Studios
Gallery, London, England

1996
Cabeza Abajo, Espacio Aglutinador, Havana, Cuba
Lágrimas de Tránsito, Centro de Arte Contemporáneo
Wifredo Lam, Havana, Cuba

1997
El Peso de la Culpa, Tejadillo 214, Havana, Cuba

Anima, The Base Space, The School
of the Art Institute of Chicago

1999
Recent Work, Vera van Laer Gallery, Antwerp, Belgium
Lo que me Corresponde, Museo de Arte Contemporáneo,
Guatemala City, Guatemala

2001
La Isla en Peso, Casa de las Américas, Havana,
and LiebmanMagnan Gallery, New York

2002
Ingeniero de Almas, Palacio de Abrantes, Salamanca, Spain
Tania Bruguera-Ghada Amer, San Francisco Art Institute

2003
Esercizio di Resistenza, Franco Soffiantino Arte
Contemporanea Gallery, Turín, Italy
Autobiografía, Museo Nacional de Bellas Artes, Havana,
Cuba
Molino Cubano, Byrd Hoffman Watermill Foundation,
Southampton, New York

2004
Dated Flesh, Rhona Hoffman Gallery, Chicago

2005
Boca a Boca, Galería Habana, Havana, Cuba
Caída Libre, Subcity Projects, Chicago

2006
For Sale, Juana de Aizpuru Gallery, Madrid, Spain
Maintenant, Ici, Là-bas, Frac Lorraine, Metz, France
Tatlin's Whisper #2, Kunsthalle Zu Kiel, Germany
Portraits, Kunsthalle Wien, Vienna, Austria
Beckett... Have You Ever Seen My Eyes?, Rhona Hoffmann
Gallery, Chicago

2007
Delayed Patriotism, Performa 07, Bronx Museum
of the Arts, New York
Giordano Bruno's Process for a Patron Saint of Political Memory,
Museo Laboratorio di Arte Contemporaneo, La Sapienza
Università di Roma, Instituto Italo Latinomericano,
Rome, Italy

2008
Object of Desire (Selling Cuba), Le Plateau, Paris, France,
and Artissima 15, Torino, Italy

2009
Tatlin's Whisper #6. Integración y Resistencia en la Era Global,
10ma Bienal de la Habana, Centro de Arte Contemporáneo
Wifredo Lam, Havana, Cuba
*Estado de Excepción. Arte de Conducta, Integración y Resistencia
en la Era Global*, 10ma Bienal de la Habana,
Galería Habana, Havana, Cuba

• • •

SELECTED GROUP EXHIBITIONS

1986
Proteo, Galería Leopoldo Romañach, Academia de Artes
Plásticas San Alejandro, Havana, Cuba

1987
I Festival de la Creación y la Investigación, Instituto Superior
de Arte, Havana, Cuba

1988
No por Mucho Madrugar Amanece Más Temprano,
Fototeca de Cuba, Havana, Cuba

El ISA en Casa, Casa de las Américas, Havana, Cuba

1989
II Festival de la Creación y la Investigación, Instituto
Superior de Arte, Havana, Cuba
Fotografía Manipulada, Exhibition Workshop,
Fototeca de Cuba, Havana, Cuba
Es Sólo lo que Ves (Arte Abstracto), Havana, Cuba

1992
2nd International Poster Biennial, Museo José Luís Cuevas,
Mexico City, Mexico

1993
XI International Drawing Biennial, Middlesbrough
Fine Arts Museum, Cleveland, England
La Nube en Pantalones, Museo Nacional de Bellas Artes,
Havana, Cuba
Dibujo no te Olvido, Centro de Desarrollo
de las Artes Visuales, Havana, Cuba

1994
La Otra Orilla, 5ta Bienal de la Habana, Castillo
de los Tres Reyes del Morro, Centro Wifredo Lam,
Havana, Cuba
Una Brecha entre el Cielo y la Tierra, Centro Provincial
de Artes Plásticas y Diseño, Havana, Cuba
Utopía, Galería Espada, Casa del Joven Creador,
Havana, Cuba
Salón de la Ciudad '94, Centro Provincial de Artes Plásticas
y Diseño, Havana, Cuba

1995
1st Contemporary Art Competition, Museo Nacional
de Bellas Artes, Havana, Cuba
ART/OMI International Workshop, Hudson, New York
II Bienal del Barro, Centro de Arte Contemporáneo
Lía Bermudez, Maracaibo, Venezuela
Cuba: la Isla Posible, Centre de Cultura Contemporània,
Barcelona, Spain
New Art from Cuba, Whitechapel Art Gallery, London,
and Tullie House Museum and Art Gallery, Carlisle, England
Las Formas de la Tierra, Galería Buades, Madrid, Spain

1996
23a Bienal de São Paulo, Parque do Ibirapuera,
São Paulo, Brazil
*The Visible and the Invisible—Representing the Body
in Contemporary Art and Society*, St. Pancras Church,
Institute of International Visual Art, London, England
La Carne, Espacio Aglutinador, Havana
I Salón Internacional de Estandartes, Centro Cultural Tijuana,
Mexico, and Museo X Teresa, Mexico City, Mexico
Otras Escri(p)turas, Centro Provincial de Artes Plásticas
y Diseño, Havana, Cuba
Un Giro de Tuerca, Galería Taller de Serigrafía René
Portocarrero, Havana, Cuba
Mujeres por Mujeres, Galería Imago, Gran Teatro
de la Habana, Havana, Cuba

1997
Trade Routes, 2nd Johannesburg Biennial,
The Electric Workshop, Johannesburg, South Africa
*Troisième Manifestation International Vidéo et Art Electronique
de Champs Libres*, Montreal, Canada
*1990's Art from Cuba—a National Residency and Exhibition
Program*, Betty Rymer Gallery, The School of the Art
Institute, Chicago; Art in General, New York; and Hallwalls
Center for Contemporary Art, Buffalo, New York
Trabajo por Cuenta Propia, Arts and Letters Faculty,

University of Havana, Cuba
New Art from Cuba: Utopian Territories, Morris
and Helen Belkin Art Gallery, University of British
Columbia, Vancouver, Canada
Las Mieles del Silencio, Galería Latinoamericana,
Casa de las Américas, Havana, Cuba
El Ocultamiento de las Almas, Centro de Desarrollo
de las Artes Visuales, Havana, Cuba

1998
Art in Freedom, Boijmans van Beuningen Museum,
Rotterdam, The Netherlands
The Garden of Forking Paths, Helsinski City Art Museum,
Helsinski, Finland; Kunstforeningen, Copenhagen,
Denmark; and EdsuikKunst & Kultur, Stockholm, Sweden
II Salón de Arte Contemporáneo, Centro de Arte
Contemporáneo Wifredo Lam, Havana, Cuba
La Dirección de la Mirada, Stadhaus, Zürich, and Musée
des Beaux Arts, La Chaux-de-Fonds, Switzerland
Obsesiones, Centro de Arte Contemporáneo Wifredo Lam,
Havana, Cuba
De Discretas Autorías: Cuba y Venezuela, Nuevas Poéticas,
Museo de Arte Contemporáneo de Maracay Mario Abreu,
Maracay, Venezuela
Fragmentos a su Imán, Galería Latinoamericana,
Casa de las Américas, Havana, Cuba
III Bienal Barro de América, Museo de Bellas Artes,
Caracas, Venezuela
Desde el Cuerpo: Alegorías de lo Femenino, Museo
de Bellas Artes, Caracas, Venezuela

1999
Videodrome, The New Museum of Contemporary Art,
New York
Utopia/Distopia, 8ª Muestra Internacional de Performance,
Mexico City, Mexico
Looking for a Place, 3rd International Biennial,
SITE Santa Fe, New Mexico
Happening, Stedelijk Museum voor Actuele Kunst,
Ghent, Belgium
Cuba-Maps of Desire, Kunsthalle Wien, Vienna, Austria

2000
Uno Más Cerca del Otro, 7ma Bienal de la Habana,
Fortaleza de San Carlos de la Cabaña, Galería
de Contraminas de San Ambrosio, Havana, Cuba
Arte all Arte, 5th edition, Fortezza di Poggio Imperiale,
Arte Continua, Poggibonsi, Italy
Exótica Incógnita, 3rd Kwangju Biennial, Korea
Cutting Edge, ARCO: Feria de Arte Contemporáneo,
Madrid, Spain

2001
A Little Bit of History Repeated, Kunst Werte, Berlin, Germany
Mercancías, Espacio C, Cantabria, Spain
Span, International Performance Arts Residency Project,
London, England

The Plateau of Humankind, 49th Venice Biennale, Italy
Do You Have Time?, LiebmanMagnan Gallery, New York
Project Room, Algunas Islas, ARCO: Feria de Arte
Contemporáneo, Madrid, Spain

2002
Fusion Cuisine, Deste Foundation, Athens, Greece
Extreme Existence, The Rubelle and Norman Schafler Gallery,
Pratt Institute, New York
Documenta 11, Kassel, Germany
The Stone and Water, Helsinki Art Museum,
Helsinki, Finland
No Place, IFA Gallery, Bonn, Germany
III Bienal de Lima, Peru
F.A.I.R, The Royal College, London, England

2003
The Real, Royal Trip, PS1 Contemporary Art Center, New
York, and Palacio del Patio Herreriano, Valladollid, Spain
Poetic Justice, 8th Istanbul Biennial, Turkey
The Living Museum, Museum für Modern Kunst,
Frankfurt, Germany
*Utopia/Post-Utopia: Conceptual Photography
and Video from Cuba*, Samuel Dorsky Museum of Art,
State University of New York, New Paltz

2004
Art Projects, Art Basel, Miami
Produciendo Realidad, Lucca, Italy
Techniques of the Visible, Shanghai Biennial, China
Island Nations, RISD Museum of Art, Providence,
Rhode Island

2005
The Hours - Visual Arts in Contemporary Latin America,
Irish Museum of Modern Art, Dublin, Ireland
The Experience of Art, 51st Venice Biennale, Italy
Fear, Art and Gallery, Milan, Italy
Editions for Venice Biennale, Edition Schellmann,
Munich, Germany
3rd Tirana Biennial, Albania
Old News, Los Angeles Contemporary Exhibitions
Revolution is on Hold, Centro per l'Arte Isola, Milan,
and L'Accademia Carrara di Belle Arti di Bergamo, Italy

2006
I Like Politique and Politique Likes Me, Montévidéo,
Marseille, France
*Sublime Embrace: Experiencing Consciousness in Contemporary
Art*, Art Gallery of Hamilton, Canada
Waiting List: Time and Transition in Cuban Contemporary Art,
City Art Museum Ljubljana, Slovenia
Biennale Cuvée, O.K. Centrum für Gegenwartskunst,
Linz, Austria
Estrecho Dudoso, Museo de Arte y Diseño Contemporáneo,
San José, Costa Rica and Teorética, San José, Costa Rica
Un Nuevo y Bravo Mundo, Consejería de Cultura y Deportes

de la Comunidad de Madrid, Spain
En Las Fronteras, Museo Extremeño e Iberoamericano
de Arte Contemporáneo, Badajoz, Spain
Not I: A Samuel Beckett Centenary Celebration, Museum
of Contemporary Art, Chicago

2007
Rethinking Dissent, 4th Göteborg Internationella
Konstbiennial for Contemporary Art, Sweden
We are Your Future, 2nd Moscow Biennale of Contemporary
Art, Russia
Global Feminisms, Brooklyn Museum, New York

2008
Prisioner's Dilemma, Cisneros Fontanals Art Foundation
CIFO, Miami
Reflections, Rhona Hoffman Gallery, Chicago
7 + 1 Project Rooms, Museo de Arte Contemporáneo
MARCO, Vigo, Spain
Inauguration du Centquatre, Centquatre Etablissement
Artistique de la Ville de Paris, France
7th Gwangju Biennale, South Korea
La Foule: Zero>Infini Chapitre 2 (Contrôle - Chaos), l'Espace
d'Art Contemporain La Tôlerie, Clermont-Ferrand, France
1968-1989, Muzeum Sztuki Nowoczesnej, Warsaw, Poland
Triennial Prologue 2: Exiles, Tate Britain, London, England
NeoHooDoo, Menil Collection, Houston, and PS1
Contemporary Art Center, New York
In Transit, Haus der Kulturen der Welt, Berlin, Germany
VI Encuentro Internacional de Performance, Instituto Valenciano
de Arte Moderno IVAM, Valencia, Spain
Our Literal Speed, ZKM, Karlsruhe, Germany
Eloquent Papers, Gallery Paul Kusseneers, Brussels, Belgium
Arte no es Vida: Actions by Artists of the Americas, 1960-2000,
El Museo del Barrio, New York
Live Living Currency, Tate Modern, London, England
Cuba: Art and History from 1868 to Today, The Montreal
Museum of Fine Arts, Canada

2009
The Fear Society, 53rd Venice Biennale, Italy
*Elles@centrepompidou: Artistes Femmes dans les Collections
du Centre Pompidou*, Centre Georges Pompidou, Paris, France
Cintas Fellowship Exhibition, Patricia & Phillip Frost Art
Museum, Miami
*Our Literal Speed (OLS): Events in the Vicinity of Art
and History*, Merchandise Mart, Chicago
Américas Latinas: Las Fatigas del Querer, Spazio Oberdan,
Milan, Italy
Bside1self, Ecole Nationale Supérieure des Beaux-Arts,
Paris, France
*Autosabotaje: Séminaire Modèle à Construire, la Culture
comme Stratégie de Survie*, Galerie Nationale
du Jeu de Paume, Paris, France
Performance Saga Festival, Lausanne, Switzerland
Re.act.feminism: Performance Art of the 1960s & 70s Today,
Akademie der Künste, Berlin, Germany

2010
Tania Bruguera: On the Political Imaginary, Neuberger
Museum of Art, Purchase College, State University of New
York, Purchase

. . .

COLLECTIONS

The Bronx Museum of the Arts, New York
Centro de Arte Contemporáneo Wifredo Lam, Havana,
Cuba
Colección Barro de América, Maracaibo, Venezuela
Daros Foundation, Zurich, Switzerland
El Museo del Barrio, New York
JP Morgan Chase Collection, New York
Instituto Valenciano de Arte Moderno IVAM, Valencia,
Spain
MMK Museum für Moderne Kunst, Frankfurt am Main,
Germany
Museo Nacional de Bellas Artes, Havana, Cuba
Museum of Modern Art, New York
Omi International Arts Center, Ghent, New York
Tate Modern, London, England
The New Museum of Latin American Art, Essex, England

SELECT BIBLIOGRAPHY

• • •

BOOKS

Bondil, Nathalie. *Cuba: Arte e Historia desde 1868 hasta Nuestros Días*. Montreal: The Montreal Museum of Fine Arts, with Prestel, Hazan, and Lunwerg Publisher, 2008.

Brito, Orlando, Carolina Ponce de León, Marcos Lora and Jack Beng-Thi. *Espacio C*. Camargo, Spain: Espacio Interdisciplinario Internacional de Arte Contemporáneo, 2002.

Bruguera, Tania in *Blickwechsel: Lateinamerika in der zeitgenössischen Kunst*. ed. Bielefeld: Transcript Verlag, 2007.
– "Postwar Memories" in *By Heart/De Memoria: Cuban Women's Journeys In and Out of Exile*. ed. María de los Angeles Torres. Philadelphia: Temple University Press, 2003.
– "El Peso de la Culpa" in *Corpus Delecti: Performance Art of the Americas*. ed. Coco Fusco. London: Routledge, 1999.
– "Multiple Identities, Invisible Identities, Invisible Behavior" in *La Generazione delle Immagini: Racconti d'Identità #7*. ed. Roberto Pinto. Milan: Comune di Milano, 2002.

Camnitzer, Luis. *New Art of Cuba*. Austin, Texas: University of Texas Press, 1994.

Dailey, Meghan, Jane Harris and Sarah Valdés. *Curve: the Female Nude Now*. New York: Universe Publishing, Rizzoli International Publications, Inc., 2003.

De Maison Rouge, Isabelle. *Mythologies Personnelles: L'Art Contemporain et L'Intime*. Paris: Scala, 2004.

Figueroa, Eugenio Valdés, Orlando Hernández, Gerardo Mosquera, and Antonio Eligio Tonel in *Art Cuba: The New Generation*. ed. Holly Block. New York: Harry N. Abrams, Inc., 2001.

Goldberg, RoseLee. *Performance Live Art since 1960*. New York: Harry N. Abrams, Inc., 1998.

Grosenick, Uta. *Art Now*. Vol. 2. Koln, Germany: Taschen, 2005.

Heartney, Eleanor. *Art & Today*. New York: Phaidon Press Limited, 2008.

Howe, Linda S. *Transgression and Conformity: Cuban Writers and Artists After the Revolution*. Madison, Wisconsin: The University of Wisconsin Press, 2004.

Krüger, Juliane in *XXD11: Über Kunst und Künstler der Gegenwart, Ein Nachlesebuch zur Documenta 11*. ed. Bernhard Balkenhol, Heiner Georgsdorf, and Pierangelo Maset. Kassel, Germany: Kassel University Press, 2002. Interview with the Artist.

Lucie-Smith, Edward. *Art Tomorrow*. Paris: Pierre Terrail, 2002.

Matt, Gerald. *Interviews*. Vienna: Kunsthalle Wien, 2007. Interview with the Artist.

Muñoz, José. "Performing Greater Cuba: Tania Bruguera and the Burden of Guilt" in *Holy Terrors: Latin American Women Perform*. ed. Roselyn Constantino and Diana Taylor. New York: Tisch, 2003.

Salabert, Pere. *Pintura Anémica, Cuerpo Suculento*. Barcelona: Laertes, 2003.

Who Cares. New York: Creative Time Books, 2006. Conversation with the Artist.

Zaya, Octavio in *Fresh Cream: Contemporary Art in Culture*. London: Phaidon Press, 2000.

• • •

EXHIBITION CATALOGUES

23 Bienal de São Paulo (Brochure). Havana: Consejo de las Artes Plásticas, 1996. Text by Juan Antonio Molina.

23 Bienal Internacional de São Paulo. São Paulo: Fundacio Bienal de São Paulo, 1996. Text by Nelson Herrera Ysla.

23 Bienal Internacional de São Paulo. Havana: Centro de Arte Contemporáneo Wifredo Lam, 1996. Text by Juan Antonio Molina.

1990's Art from Cuba. New York: Art in General, 1997. Texts by Valerie Cassel, Betti-Sue Hertz, et al. Interview with the Artist by Betti-Sue Hertz.

A Little Bit of History Repeated. Berlin: KW, 2001. Text by Tania Bruguera.

Ana Mendieta: Earth Body, Sculpture and Performance, 1972-1985. Washington: Hirshhorn Museum and Sculpture Garden, 2004. Text by Olga Viso.

Annual Report: A Year in Exhibitions. Gwangju, South Korea: The 7th Gwangju Biennale, 2008. Text by Okwui Enwezor.

Art no es Vida: Action by Artists of the Americas. New York: El Museo del Barrio, 2008. Text by Deborah Cullen.

Arte all Arte '00. San Gimignano, Italy: Associazione Arte Continua, 2000. Text by Roberto Pinto.

Arte Cubano: Más Allá del Papel. Madrid: Caja, 1999. Text by Llilian Llanes.

Poetic Justice: 8th Istanbul Biennial. Istanbul,
Turkey: Istanbul Foundation for Culture and Arts, 2003.
Text by Suset Sánchez.

Caribe Insular. Madrid: Casa de America, 1998.

Contemporary Art from Cuba.
New York: Delano Greenidge Editions, 1998.
Texts by Gerardo Mosquera and Antonio Eligio
Fernández (Tonel).

Cuba Avant-Garde: Contemporary Cuban Art from the Farber
Collection. Gainesville, Florida: Samuel P. Harn Museum
of Art, 2007. Texts by Abelardo G. Mena Chicuri,
Kerry Oliver-Smith, and Magda Gonzáles-Mora Alfonso.

Cuba: La Isla Posible. Barcelona: Centro di Cultura
Contemporània de Barcelona, 1995.
Texts by Ivan de la Nuez, Gerardo Mosquera,
Rafael Rojas, et al.

Cuba: Los Mapas del Deseo. Wien, Austria: Kunsthalle Wien,
1999. Texts by Gerardo Mosquera and Eugenio Valdés
Figueroa. Interview with the Artist by Octavio Zaya.

Cuba Siglo XX. Modernidad y Sincretismo. Las Palmas
de Gran Canaria, Spain: Centro Atlántico de Arte Moderno,
1996. Texts by Ivan de la Nuez, Gerardo Mosquera,
Antonio Zayas, et al.

De Discretas Autorias. Cuba y Venezuela: Nuevas Poéticas.
Maracay, Venezuela: Museo de Arte Contemporáneo
de Maracay Mario Abreu, 1998. Text by Nydia Gutierrez.

Documenta 11 Platform 5: Austellung/Exhibition.
Kassel, Germany: Hatje Cantz Verlag Publishers, 2002.
Texts by Tania Bruguera and Stephanie Mauch.

En las Fronteras: Arte Latinoamericano en la Colección
del MEIAC. Badajoz, Spain: MEIAC, 2008.
Text by Antonio Franco Domínguez.

Extreme Existence. New York: Pratt Manhattan Gallery, 2002.
Text by Tania Bruguera.

Fragmentos a su Iman. Havana: Casa de las Américas, 1994.
Text by Tamara Díaz Bringas.

Fusion Cuisine. Athens, Greece: Deste Foundation, 2002.
Texts by Katerina Gregos and Jo Anna Isaak.

Global Feminisms: New Directions in Contemporary Art.
New York: Brooklyn Museum, 2007. Text by Maura Reilly.

Il Salón de Arte Cubano Contemporáneo. Havana:
Centro de Desarrollo de las Artes Visuales, 1998.

Island Nations. Providence, Rhode Island: Museum of Art,
Rhode Island School of Design, 2004.
Text by René Morales.

La Dirección de la Mirada. Wien: Springer, 1999.
Texts by Abelardo G. Mena Chicuri, Gerardo Mosquera,
and Jorge Angel Pérez.

La Isla en Peso. Havana: Casa de las Américas, 2001.
Text by Eugenio Valdés Figueroa.

Labores Domésticas. Havana: Union, 2004.
Text by Dannys Montes de Oca.

Lida Abdul/Tania Bruguera: Maintenant Ici là-Bas
(Now Here, Over There). Lorraine, France: Fonds Régional
d Art Contemporain de Lorraine, 2006. Texts by Beatrice
Josse, Nikos Papastergiadis, and Yuneikys Villalonga.

Lo que me Corresponde. Guatemala City, Guatemala:
Museo Nacional de Arte Moderno, 1999.
Interview with the Artist by Valia Garzón.

NeoHooDoo: Art for a Forgotten Faith. Houston,
Texas: The Menil Collection, 2008. Text by Franklin Sirmans.

New Art from Cuba. London: Whitechapel Art Gallery, 1995.
Text by Antonio Eligio Fernández (Tonel).

Pulse: Art, Healing and Transformation.
Boston: The Institute of Contemporary Art, 2003.
Texts by Stephanie Mauch and Jessica Morgan.

Short Stories, New Narrative Forms in Contemporary Art.
Milan: Comune di Milano, La Fabbrica del Vapore, 2001.
Text by Eugenio Valdés Figueroa.

Tania Bruguera. Chicago: Lowitz and Sons, 2005.
Interview with the Artist and Text by RoseLee Goldberg.

Tania Bruguera: Artist Project and Residency (Brochure).
San Francisco: San Francisco Art Institute, 2002.
Text by Karen Moss.

Tania Bruguera: Esercizio di Resistenza.
Turin, Italy: Franco Soffiantino Arte Contemporanea, 2003.
Text by Roberto Pinto.

Tania Bruguera: Portraits. Vienna: Kunsthalle Wien, 2006.
Texts by Gerald Matt, Dirk Luckow, Silvia Holler,
and Tania Bruguera.

The Garden of Forking Paths. Contemporary Artists
from Latin America. Copenhagen: Kunstforeningen, 1999.
Text by Octavio Zaya.

The Monsoon Collection. London: Monsoon Art Collection, 2007. Text by Sir Nicholas Serota.
The Real Royal Trip. New York: PS1 Contemporary Art Center, 2003. Text by Kevin Power.

Trade Routes: 2nd Johannesburg Biennale. New York: Johannesburg Metropolitan Council, The Prince Claus Fund for Culture and Development, 1997.
Text by Okwui Enwezor.

Utopia/Post-Utopia: Conceptual Photography and Video from Cuba. New Paltz: Samuel Dorsky Museum of Art, State University of New York, 2003.
Texts by Helaine Posner and Eugenio Valdés Figueroa.

Vigilantes: The Dream of Reason. Toronto, Canada: Fado, 2004. Texts by Tania Bruguera, Tagny Duff, and Erin Manning.

• • •

SELECTED JOURNALS

Anselmi, Ines. "Kunst, Macht und Marginalität. 5ª Biennale von Havanna." *Kunstforum International* no. 128. (October/December 1994): 318-325.

Arratia, Eurídice. "Cityscape Havana." *Flash Art* 32, no. 204. (January/February 1999): 48. Interview with the Artist.

Auerbach, Ruth. "Sexta Bienal de la Habana: La Rebellion de las Contradicciones." *Estilo* 8, no. 32. (December 1997): 59-62.

Avant, Tricia. "Our Flesh, Ourselves." *Meatpaper* 1, no. 1. (September 2007): 10-11.

Bayliss, Sarah. "Putting on the Lamb." *ARTnews* 103, no. 9. (October 2004): 164-167.
– "Best Bets." *ARTnews* (Summer 2001): 150-151.

Birringer, Johannes. "Art in America (the Dream): A Conversation with Tania Bruguera."
Performance Research 3, no. 1. (Spring 1998): 24-31.

Bishop, Claire. "Speech Disorder: Claire Bishop on Tania Bruguera at the 10th Havana Biennial." *Artforum* 47, no. 10. (Summer 2009): 121-122.

Bruguera, Tania. "Tania Bruguera: When Behavior Becomes Form." *Parachute Contemporary Art* no. 125. (January/March 2007): 62-70.
– "Trust Workshop: Opening Reception Russia 2007." *Printed Project* no.7. (June 2007): 27-38.
– "Untitled (Havana, 2000)." *Boundary* 2 29, no. 3. (Fall 2002): 43-46.

Cameron, Dan. "Cuba: Still Not Libre." *Art and Auction* 16, no. 8. (March 1994): 86-91.

Camnitzer, Luis. "Los Latinos." *Art Nexus* 3, no. 52. (April/June 2004): 66-69.
– "Memoria de la Postguerra." *Art Nexus* no. 15. (January/March 1995): 29-30.
– "La V Bienal de La Habana." *Art Nexus* no. 14. (October/December 1994): 48-55.

Castellanos, Lázara. "Discurso de Mujeres: una Reflexión dentro de las Artes Visuales Cubanas." *Artecubano* no. 2. (1998): 18-25.
– "Tania Bruguera, Sandra Ceballos." *Lo Que Venga* 2, no. 1. (1995): 20-21.

Castillo, Héctor Antón. "Con-tratiempos al Margen." *Artecubano* no. 1 (2004): 14.
– "El 'Arte Útil' de Tania Bruguera," *Artecubano* no. 2. (2008): 92-93.

Cazalla, Jana. "Quinta Bienal de la Habana: Encuentros en la Periferia." *Lápiz* 12, no. 106. (1994): 74-81.

Cembalest, Robin. "Where Rube Goldberg Meets Kafka." *ARTnews* 100, no. 2. (February 2001): 150-151.

Chambert, Christian. "The 7th Havana Biennial." *The Nordic Art Review* 3, no. 1. (2001): 86-87.

Christmann, Holger. "Kuba-jenseits von Castro." *Format* no. 11/15. (1999): 142-143.

Cippitelli, Lucrezia. "Dalla Cattedra all'Arte Deconducta, un Incontro con Tania Bruguera." *Luxflux Prototype Arte Contemporánea* 3, no. 10-12. (April 2005): 22-31. Interview with the Artist.

De la Nuez, Ivan. "Nuevos Mapas y Viejas Trampas." *Lápiz* 13, no. 103. (May 1994): 35-39.

Desnoes, Edmundo. "Arte o Muerte: Sobreviviremos." Unpublished.

Eligio Fernández (Tonel), Antonio. "A Tree from Many Shores: Cuban Art in Movement." *Art Journal* 57, no. 4. (Winter 1998): 62-73.

Fadraga Tudela, Lillebit. "Fragmentaciones y Otros Vicios Secretos en la Obra de Tania Bruguera." *La Gaceta de Cuba* no. 6. (November/December 2000): 41-43.

Fenz, Werner. "Künstlerisches Handeln mit physischem Material. Zu den gesellschaftspolitischen Fabeln von Tania Bruguera." *Lichtungen* 25, no. 98. (2004): 117-132.

Flores, Tatiana. "The Real Royal Trip." *Art Nexus* 3, no. 52. (April/June 2004): 159-160.

Florez, Fernando Castro. "Las 10 Imprescindibles." *Descubrir el Arte* 8, no. 85. (March 2006): 32-42.

González, Magda Ileana. "Obsesiones." *Artecubano* no. 1. (1999): 22.

Griffin, Jonathan. "Tania Bruguera: Cuba, Performance and Society's Relationship to its History." *Frieze* no. 118. (October 2008): 286-287.

Heartney, Eleanor. "Tania Bruguera at LiebmanMagnan." *Art in America* (March 2002): 131-132.

Hernández, Erena. "Para no Olvidar a Ana." *Mujeres* 31, no. 2. (April 1992): 66-67.

Herrera Ysla, Nelson. "Arte Cubano a Vuelo de Pájaro, entre Dos Siglos." *Artecubano* no. 2. (2000): 8.

Hickey, Dave. "Best of the 90's." *Artforum* 38, no. 4. (December 1999): 112-113.

Hinchberger, Bill. "XXIII Bienal International de Sao Paulo." *ARTnews* 95, no. 11. (December 1996): 128.

Hoffmann, Jens. "Aperto Performance." *Flash Art* 33, no. 214. (October 2000): 49-51.
– "Tania Bruguera: Freedom of the Ephemeral." *Flash Art* 34, no. 225. (July/September 2002): 98-99.

Hollander, Kurt. "Report from Cuba: Art Emigration and Tourism." *Art in America* (October 1994): 41-47.

Israel, Nico. "VII Bienal de La Habana." *Artforum* 39, no. 6. (February 2001): 147-148.

Karttunen, Ulla. "Aktivistinen Taide, Aikamme Rappiotaide?" *Taide* no. 4. (April 2008): 44-45.

Ledo, Agar. "Huellas Intimas: Entrevista a Tania Bruguera." *Lápiz* no. 207. (2004): 48-63. Interview with the Artist.

Lorés, Maite. "The Art of Cuba." *Art Line Magazine* 6, no. 3. (Autumn 1995): 18-20.

Martinez, Rosa. "Cityscape on New Feminism." *Flash Art* 33, no. 214. (October 2000): 53-56. Interview with the Artist.

Molina, Juan Antonio. "Entre la Ida y el Regreso, la Experiencia del Otro en la Memoria." *Artecubano* no. 1. (1997): 68-70.

Mosquera, Gerardo. "Resucitando a Ana Mendieta." *Poliéster* 4, no. 11. (Winter 1995): 52-55.

Nardo, Francescadi. "Arte de Conducta." *Janus* 8, no. 22. (January 2007): 78-83. Interview with the Artist.

Narea, Ximena. "Cuba: 5ma Bienal de la Habana. Arte de Tres Continentes." *Heterogénesis* no. 8/9. (September 1994): 4-7.

Navarro, Wendy. "Arqueología del Alma o de la Realidad. La Mirada Femenina en el Arte Cubano Contemporáneo." *Atlántica Internacional* no. 22. (Winter 1999): 111-116.

Negrín, Javier. "Una Tribuna." *La Gaceta de Cuba* no. 1. (January/February 2004).
– "En la Piel del Cordero." *Noticias de arte cubano* 2, no. 7. (July 2001).

Ottmann, Klaus. "Kwangju Biennale 2000." *ARTnews* (June 2000).
– "Man and his Environment at the Kwangju Biennial." *Domus 827* (June 2000): 91.

Pearlman, Ellen. "The Fallacy of Utopia: the Art Work and Current Dialectic in Havana, Cuba." *The Brooklyn Rail* (Summer 2002): 18-19.

Perez-Rementeria, Denorah. "Performance: An Open-Heart Operation on Selected Works by Tania Bruguera." *Art Nexus* 7, no. 70. (2008): 94-99.

Phillips, Jen. "Tea with Tania." *Girlfriends* (July 2002): 24.

Pozo, Alejandra. "Cuerpos de Artistas en Plena Acción. Performances durante y alrededor de la Bienal." *Art Nexus* no. 26. (October/December 1997): 77-79.
– "La Habana, Mayo de 1997: Arte Off-icial." *Estilo* 8, no. 32. (May/December 1997): 62-65.

Quirós, Luis Fernando. "Tania Bruguera: el Enigma de lo Enigmático." *Fanal* 2, no. 13. (March/April 1996): 19-23.

Ribeaux, Ariel. "Silencio en el MuNAM." *Noticias de Arte Cubano* 1, no. 1. (March 2000): 5.
– "Work in Progress, Tania Bruguera y lo que nos Corresponde." *Heterogénesis* 8, no. 27. (July 1999): 50-55.

Roelandt, Els. "Als Een Schaap Geslacht." *Tijd Cultur* 2, no. 53. (April 14, 1999).

Sanders, Mark. "Cuba Confronted." *What's On* (March 15, 1995).

Scholette, Gregory. "Affirmation of the Curatorial Class." *Afterimage* 28, no. 5. (November 14, 2000): 6-7.

Stocchi, Francesco. "A Presence You Can't Avoid: An Interview with Tania Bruguera." *UOVO Magazine* no. 17. (April/May/June 2008): 174-192. Interview with the Artist.

Suárez, Ezequiel. "Lo que no Vemos (Coronografía Paroscópica)." *Lo que venga* 2, no. 1. (1995).

"Tania Bruguera." *Kunstforum* no. 161.
(August/October 2002): 238-241.

Thin, Von Ute. "Kubas Rebellische Tochter."
Art Magazine no. 6. (June 2002): 48-53.

Turner, Grady. "Sweet Dreams." *Art in America* 89, no. 10.
(October 1, 2001): 72-77.

Valdés Figueroa, Eugenio. "Reviva la Revoltaire."
Conjunto no. 112-113. (January/June 1999): 55.
– "Art Cuba. The Mask: Utopia and Ideology." *Flash Art* 30,
no. 192. (January/February 1997): 53-55.
– "Horizontal Interactions: Pedagogy and Art in
Contemporary Cuba." *Parachute Contemporary Art* no. 125.
(January/March 2007): 56-87.

Weinstein, Joel. "Art and Agitprop, Who's Ox is It,
Anyway? Tania Bruguera's Autobiografía," *Art Papers*
(March/April 2005): 30-33.

Wood, Yolanda. "La Aventura del Silencio
en Tania Bruguera." *Arte Cubano* no. 3. (2000): 34-37.

Zeyer, René."Musik als Kraftwerk der Gefühle."
Profil 11, no. 15. (1999): 130-135.

. . .

SELECT NEWSPAPERS

Anselmi, Ines. "Kunst del Peripherie im Zentrum."
Zürichesee-Zeitung (June 9, 1994): 20.

Breerette, Genevieve."Tania Bruguera, le Corps, la Société
et la Politique." *Le Monde* (Paris, France) (December 5, 2000).

Camhi, Leslie. "Verse into Video." *The Village Voice* 46, no. 43.
(October 30, 2001): 55.

Camper, Fred. "Performance Provocateur." Chicago Reader
(January 20, 2006): 22.

Cantor, Judy. "Art in Cuba." *Miami New Times* 9, no. 8.
(June 8, 1994): 14-26.

Carlozo, Lou. "Cuban Performance Artist on a Mission of
Cultural Healing." *The Chicago Tribune* (March 20, 1997): 1/4.

Cotter, Holland. "Tania Bruguera 'La Isla en Peso'."
The New York Times (November 2, 2001).
– "A New Latino Presence, Remixed and Redistilled."
The New York Times (November 28, 2003).

Echevarria, Maurice. "Tania Bruguera: descenso
del performance." *El Periódico* (Guatemala City, Guatemala)
(April 23, 1999): 17.

Faulkner, Tamara. "Critic's Choice: Tania Bruguera"
Chicago Reader (March 5, 2004): 25.

Fischer, Jack. "Cuban Brings a Disturbing 'Behavior Art'."
San Jose Mercury (January 24, 2002): 3E.

Fusco, Coco. "Cuba's Art World Comes Undone."
Los Angeles Times (December 24, 1996): F1/F7.

Ghezzi, Rosella. "Una Generazione allo Specchio."
Corriere della Sera (January 24, 2001): 37.

Helguera, Pablo."Tania Bruguera Explora la Relación entre
Dejar la Patria y no Tener Casa." *Éxito* (March 13, 1997): 20.
– "Migración y Desamparo." *Éxito* (March 13, 1997): 26.

Levin, Kim. "The CNN Documenta." *The Village Voice*
(July 9, 2002): 57.
– "Art and Contradiction at the Havana Bienal: Cuba Libre."
The Village Voice 45 no. 51. (December 26, 2000): 129-130.

Medina, Cuauhtémoc. "Lo Real Habana." *Curare,*
suplemento de *La Jornada* (June 4, 1994): 12-13.

Milroy, Sarah. "The Sly Politics of Cuban Art."
The Globe and Mail (April 5, 1997): C5.

Ribeaux, Ariel. "Performance, Actitud, Gesto y Miradas
Diferentes." *El Acordeón,* cultural supplement of
El Periódico (November 21, 1999): 2B-3B.

Rockwell, John. "Who're You Calling Minimalist?"
The New York Times (August 5, 2003).

Santiago, Fabiola. "Artist's Work Lets Cubans Speak Out
in Havana for Freedom." *The Miami Herald* (March 31, 2009).

Wessel, Von Thomas. "Hey, ich hab'ne Pistole!
Bruguera-performance." *Die angst des statisten vor dubiosen
machtfantasien* (June 28, 2002).

Tribute to Ana Mendieta, 1985–1996
Re-enactment of performance work by the artist
Gunpowder, stones, and fabric
Dimensions variable

Memory of the Postwar I, 1993
Collaboration with Cuban artists, black ink, and newsprint
13 2/5 x 8 2/5 inches
Artist book collection, MoMa, New York

Memory of the Postwar II, 1994
Collaboration with Cuban artists inside and outside Cuba,
black ink, and newsprint
12 1/5 x 8 1/5 inches
Artist book collection, MoMa, New York

Table of Salvation, 1994
Marble, cotton, and wood
Dimensions variable

Head Down, 1996
Bodies of Cuban artists, art critics, art history students,
audience members, gallerists, and curators, lamb's wool,
white paint, flag, red cloth, and political songs created
during the early years of the Cuban Revolution
Dimensions variable

Studio Study, 1996
Pedestal, metal, iron, cotton, and raw meat
Dimensions variable

The Burden of Guilt, 1997–99
Re-presentation of an historical event
Decapitated lamb, rope, water, salt, and Cuban soil
Dimensions variable

Displacement, 1998–99
Embodiment of a Nkisi Nkonde icon
Cuban earth, glue, wood, nails, fabric, and video
Dimensions variable

Untitled (Havana, 2000), 2000
Video performance installation
Cubans, milled sugar cane, black and white monitor,
and DVD player and disc
Dimensions variable

Untitled (Kassel, 2002), 2002
Video performance installation
Germans, guns, black outfits, wood scaffolding,
40 750 watt lights, projector, and DVD player and disc
Dimensions variable
MMK Museum für Moderne Kunst, Frankfurt/Main
Purchased with the generous support of the 3 x 8 Fond, a
city of Frankfurt/Main
initiative by 12 Frankfurt-based companies

Poetic Justice, 2002–03
Video installation
Used tea bags, 8 videos from historic newsreels, 8 LCD
screens, 8 DVD players and discs
Dimensions variable
La Gaia Collection, Italy

Autobiography (Version inside Cuba), 2003
Painted white space, 2 Soviet speakers from the 1970s,
security guard, egg carton, wood stage, 16 subwoofers,
disconnected microphone, 3 unfinished sheet rock walls,
and electric bulb
Dimensions variable
Courtesy Daros-Latinamerica Collection, Zürich

Memory of the Postwar III, 2003
Newspaper without a name, date or news, political slogans
used by the Cuban Revolution, reproduction of posters
of the slogans, red ink, black ink, and newsprint
11 1/5 x 15 9/10 inches

L'accord de Marseille, 2006
Collaboration with J. Castro
Lawyer, notary public, payment for services, and legal
agreement

Untitled (Moscow, 2007) or Trust Workshop, 2007
Former KGB agent, street photographer, eagles, monkeys,
photographic paper, printer, ink, and photograph of Felix
Dzerzhinsky
Dimensions variable

Tatlin's Whisper #6 (Havana Version), 2009
Stage, podium, microphone, loudspeakers, curtain,
2 people in military fatigues, dove, and audience
Dimensions variable
Berezdivin Collection, San Juan, Puerto Rico

Untitled (Bogotá, 2009), 2009
An archive of internet responses

Untitled (Palestine, 2009), 2009
A political proposal

Survey, 2010
Docents who are blind

All works are collection of the artist except as noted.

To find out more about Charta,
and to learn about our most recent publications, visit

www.chartaartbooks.it

Printed in December 2009
for Edizioni Charta